METAMORPHOSES

PHOTOGRAPHY
IN THE
ELECTRONIC AGE

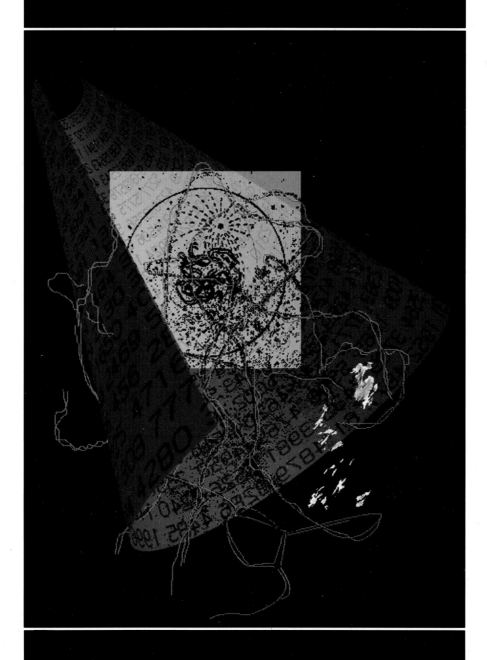

INTRODUCTION BY
MARK HAWORTH-BOOTH

APERTURE

Paul Thorel,
Richard S.,
1992

INTRODUCTION

There is, in the Victoria and Albert Museum, a celebrated landscape photograph from 1858—Camille Silvy's *River Scene, France*—which is very beautiful and remarkably complicated. The museum is currently devising a small exhibition around this photograph. The idea is to use computers and the Adobe Photoshop program to give visitors the fun of "deconstructing" the photograph. Monsieur Silvy, faced with the stunningly fast and detailed but still not quite satisfactory new photo technology of the 1850s—featuring glass negatives—actually had to expose one negative for the sky, another for the landscape. To compensate for the relatively heavy sky, he "burned-in" the river foreground. At the point where the two negatives join, he delicately painted a line of cloud on the negative. Handmade cloud trails the horizon, deceives the viewer—it was the late Ansel Adams, one of the most accomplished landscape photographers ever, who pointed out this sleight of hand to my disbelieving eye.

In fact Silvy flicked his pencils and brushes all around the trees, altering the image much as a computer nut would today, and he certainly choreographed the people who animate the banks of his river: the country bourgeoisie standing in the private garden on the left, the common people on the common land to the right. Clone the grass, remove the people, and the picture is psychologically something completely different. One really can do things that were impossible before; for example, to undo the burn-in across the base, one removes the whole foreground, flips the image over—voilà, the trees cast new reflections. So, by playing with a touch screen for two minutes, exhibition-goers will be able to pick up on how highly manipulative photography always has been. Now perhaps you'd like to just ruffle up that placid, mirror-still water. . . . See how the picture is different again. You get hooked.

In 1989, on the occasion of the 150th anniversary of the invention of photography, I wrote in an essay that "Still photography has the capacity to become as wilfully malleable as cinema. Luckily, however, we are very much used to cinema. News as fiction? That is not a particularly new idea either. The deconstruction of the old view of photography as inexorably tied to 'reality' may bring with it a necessary sharpening of attention to the claims of all media representations."

For the moment, western cultures still preserve the general idea that photographs are relatively straightforward reflections of what appeared before a lens at a particular time. This concept gets jolted around constantly, though. One opens a newspaper and reads an interview with the veteran Magnum photographer Eve Arnold: "Take Richard Avedon's picture of three stars at the Oscars; I think it was Jack Nicholson, Michelle Pfeiffer and Shirley MacLaine. I was startled by the fact that these people were all in a row. I wondered how he managed that. Then I realized something was wrong . . . it didn't look right. It had been cobbled together" (*London Daily Telegraph*, April 30, 1994).

This questioning of photographic reality hit me especially hard last year, when Pedro Meyer and Trisha Ziff came to call on me in my office at the Victoria and Albert. Pedro, whom I have known for some years and always regard as one of my slightly older and rather wiser brothers in photography, took a picture of me as I stood by the door of my office, in front of a wall full of posters from different photographic exhibitions. A couple of weeks later a print arrived from Los Angeles and I saw myself standing in my gray suit beside a white office door. I put the photograph aside because there was something wrong with it and I just couldn't see what. He'd seamlessly removed, I suddenly recognized (two days later), the image from a William Eggleston poster—and, just as seamlessly, inserted an image of his own. Actually, a masked man from some kind of carnival had slipped right past me (a supposed expert—at any rate, a paid professional—in matters of photographic connoisseurship) and taken up residence on my wall.

Pedro Meyer, and the other artists and writers represented here, work with the idea that manipulation—technical, political, psychological, and an endless menu of ramifications—is the underlying reality of our time. The images here do not so much "express" this; it's what they are. This exceptionally thought-provoking and vividly illustrated book will bring anyone curious about photography in the electronic age up to speed—just as the pace is really heating up.

Mark Haworth-Booth
Curator of Photographs,
Victoria and Albert Museum

FROM DADA TO DIGITAL

MONTAGE IN THE TWENTIETH CENTURY

BY TIMOTHY DRUCKREY

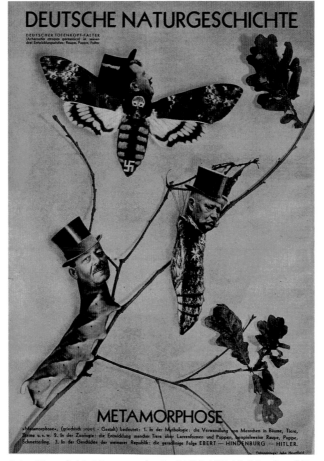

John Heartfield, *Metamorphosis*, 34/34 AIZ 13, Number 33, 16 August 1934, page 536

Photography emerged in a century during which history and temporality collided in the realm of representation. The transformation of experience through the nineteenth century was increasingly one of time and contingency; the maturation of modernity fragmented long-comforting narratives of nature and culture. Urban industrialism and clock-time challenged seemingly unassailable notions of the unity of life. What role photography played within this transformation is a subject that encompasses the whole of subjective human experience—from the construction of identity to the effects of technological change on the self in the modern era. Contingent, episodic, terse, photography forced culture to encounter its presence as historically specific and temporally loaded.

For nearly half a decade, photography recorded the effects of material cultural change. In portraiture, the image served to establish the self as a social presence. In documentary photography, the image served as a material witness to transformations of the urban environment or as icons of colonization in the imperialist expansions into "foreign" territories. The blunt urgency of the image was rationalized as scientific and objective, while its form became mediated by positivism and aesthetics. In every sense, photography established itself as a cross between absolute fact and essentialist art.

If the images of early photography were rooted in temporalities whose effects were distinctly social, a transformation would soon occur linking photography with the recording of time. It is no coincidence, for example, that in the images of Eadweard Muybridge and Étienne-Jules Marey time itself became the subject of the image. Divisible, atomistic and "masterable," time was represented as an object whose logic could be demonstrated, a process that could be deciphered.

By the turn of the century, photography was poised between Pictorialism and positivism at the same moment that science was on the brink of smashing and confounding the principles of physics. Later, with the introduction of non-Euclidean geometry, atomic theory, and the Special Theory of Relativity, the autonomous concepts of space and time that had previously grounded scientific practice were shattered. The scientific breakthroughs at the early part of the century had immediate repercussions in the arts. Revolutionary science founded revolutionary art in reconstituting representation. The "moralization of objectivity"[1] that had haunted bourgeois science through the nineteenth century was supplanted by the *mastery* of objectivity. As an epitaph, Futurist leader Fillippo Tommaso Marinetti wrote, "Time and space died yesterday."

In many ways, the entire twentieth century has been spent grappling with the rupture of continuity initiated in its first decade. From physics to the development of gene splicing, the logic of totalizing narratives has been eroding. As pertinent in the arts as

they are in physics, biology, and politics, the themes represented by fragmentation and rupture permeate our contemporary theories of identity, race, language, and dreaming, which are splintered into bits with meanings that are neither linear nor singular.

How, then, can the recent development of electronic imaging be contextualized in the history of art? The answer does not exist as a simple shift in the structure of image formation and processing, but in a larger historical shift that, on the one hand, aligns the production of signs with technology and, on the other, links technology with communication and discourse.

The technical demands surrounding the making of computer-based art often shroud the confrontation with the issue of representation. In fact, what haunts so much writing about technology is a sense that its usefulness will be usurped by inevitable upgrades. If this dubious notion of obsolescence is to be countered, it should not be with the lingering assumption that art can be loosened from its contingency, but with a clear belief that the rootedness of art is both persuasive and demanding.

Emerging from digital media there is a kind of reconfiguration of several traditions: montage, narrative, a concern with the "space" of electronics, and a rethinking or extension of the issues surrounding the semiotic constitution of the image. The terms of the deconstruction of imaging will be forced to adapt to the imperatives of digitally coded images, as well as to the aesthetic imperatives of those images, the meanings of which are no less significant than in any previous symbolic system.

Montage establishes the image as either dialectical or discursive, a collision of significations. The dialectical mission is to *fuse* fragments as concentrated form; the discursive one is to *create fissures* or interruptions in the established order. Images carry with them iconic references, references that have to do with the assemblage of ideas, that build toward a sense of totality.

This century has witnessed the breakdown of that singular iconic order in several different areas. In science, for example, atomic theory provided a kind of groundwork for what montage was going to be like; it asserted that the object exists not as a totality but as an assemblage of components. And while the arts were wholly capable of encountering the issues of spatial fragmentation, the urgency of the affiliation between science and art demanded that the issue of temporality be considered. One can understand Cubism in terms of the special character of montage—what Henri Lefebvre called "differential space." The issue of temporality was also addressed in Futurism. However, the effect of the breakup of classical objects led not only to the spatial simultaneity of Cubism, or to the violent temporal anarchy of Futurism, but to a reconfiguration of the very concept of order, the lingering positivist order of bourgeois culture.

Yet the breakthrough came from the work of the Dadaists, in which the quotidian was abandoned in favor of a direct encounter with the signifier and cultural politics.[2] The relationship between Dada and montage is, perhaps, the pivotal aspect of the deconstruction of the image-order of bourgeois culture. In Dada the image was detonated. The creativity that was linked with the idea of "creation"

was rejected in favor of an inversion of this process, in which the consumption of images and meanings penetrated more deeply into a troubled cultural order than did the novelty of originality. Artists no longer had to be "makers" of pictures; the creative act was usurped or sublated. For the first time, mass cultural images were consumed not for their aesthetic value (as in Cubism) but for their political effect. Walter Benjamin wrote about this phenomenon, understanding that the revolutionary strength of Dada lay in its challenge to art's authenticity. According to the Dadaists, every scrap of reality is art if we put a frame around it—and that frame is arbitrary. The Dadaists' motto was, "We'll take the idea of the frame and put in it

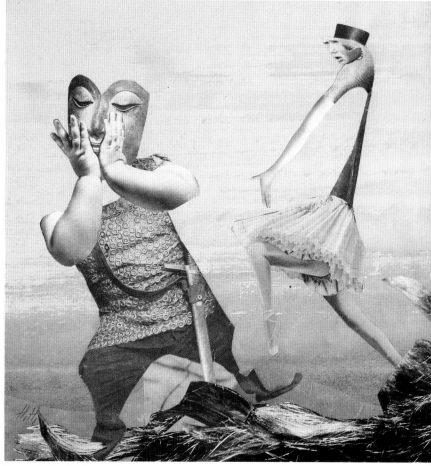

Hannah Höch, *Streit* (Argument), ca. 1930

everything that you reject, everything that you toss away, everything that you can't take seriously." Their dogma conflated transgression and shock.

The transition from Dadaist (dialectical) montage to Surrealist (allegorical) montage was a shift from cultural critique to the aestheticization of associations drawn largely from the unconscious.[3] Between them were developments in photomontage that left behind distressed simultaneities and aesthetics, and took on the issue of power as more than a symbolic struggle, as a political fact. "John Heartfield," wrote Louis Aragon in 1935, "wasn't playing anymore." Political photomontage was more directly implicated in systems of

propaganda and mass psychology. The anarchistic politics of Dada were replaced with focused attacks on Fascist representation. Shock became horror, and horror agency. Similar shifts were evident in the works of Hannah Höch, in which the aestheticized primitivism of Cubism was unequivocally usurped by issues of sexuality, advertising, gender, and power.

No image in Dadaism was held to be sacrosanct or complete; everything was to be taken apart (and didn't have to be put back together). Surrealism, by contrast, embraced fragmentation as fiction, not as repudiation. In Surrealism there wasn't so much a rupture, as an uncanny, poetic continuity created between the symbolic and the imaginary, a kind of reinvention of allegory in terms of the imagination. What complicated Surrealism was psychoanalysis, which liberated montage from its dependence on culture and allowed it to confront issues of fetishism, sexuality, the uncanny, the dream—in short, poetic issues. Surrealism took shape as an attempt to integrate the symbolic as an act of freedom emerging from the unconscious. The spatial character of Surrealist imagery is analogical, linking associations through acts of displacement and representation.

The next significant shift in the recognition of fragmentation emerged in the assimilation of consumer culture within the aesthetic practices of Pop art in the 1950s and 1960s. If Dadaists looked critically and politically at mass culture, Pop artists looked ironically at consumer culture. They suggested a form of comic Dadaism. Using the very mechanisms of repetition, much of the work addressed repetition itself, parodic repetition. In Dadaism there was no form of serial movement, while in Pop there was a tremendous interest in seriality, principally because of the relationship between mass production, mass media, and the repetitions of consumer culture. Consumer culture offered a redundant message neutralized by its surplus presence.

So, by mid century, what looked like montage raised a series of issues having to do with repetition, consumer culture, and mass production, tangentially addressing the reconfigured cultural and aesthetic space of television. Images appear as indexes of a world mediated through TV. Media icons supplanted political ones—or the distinction between the two collapsed as the "space" of the print media was being transformed by the "space" of the television screen. The site of the assimilation of social content was shifting toward the immaterial and the programmed, toward the illusory power of the medium as the message. The "space" of knowing and the "space" of perception were merging. One cannot overestimate the effect of the "space" of television in the transformation of experience. It is no exaggeration to suggest that televisual culture established what Paul Virilio would later

call the "third window," the window of the screen, or the televisual window. The efficacy of modernity as the bearer of unified narratives was shattered yet again. In some ways it was the final blow, corresponding with the shift to a postwar economy of "postindustrialization" and technology. A culture began to emerge that had witnessed the end of the spatial representation of form, and the origin of a spatial representation that is activated by an affinity with temporality, narrative, and media.

What unites Dada, Surrealism, Pop, television, and, ultimately, the computer image, is their underlying relationship with the photographic. Although photography still constitutes one of the central conditions for the representation of experience, over the past fifteen years its legitimacy has been challenged on a number of points. Yet what seems so urgent about the relationship between the hegemony of the visual in Western culture, and the circumstances in which the photograph seemed to validate such spurious notions as "truth," or "fact," is that the process of dismantling the photograph's efficacy is paralleled by an intensification of the visual through digital technology.

The consequence of this unsettled state of electronic visualization is an equivocal image. Legitimated by the conceptual models of photography and by algorithmic perception, the electronic image vacillates between actuality and hypotheses (the actual and the virtual?). The alliance between the seen and the experienced is challenged in this environment. In a culture in which accelerated images have come to constitute experience, the immediate becomes compressed and volatile. Images have never before possessed the potential to sustain so much information or, perhaps, meaning. Electronic montage; photographic-resolution animation; the erosion of photography by the increasing acceptability of video as a signifier of authenticity; the abandonment (or outright dismissal) of images as legal evidence; and, paradoxically, the concentration of images in a culture where destability is sustained by fleeting computerized optical forms—all these elements conspire to suggest a refunctioned persuasiveness of vision. The transformation of knowledge generated by so-called postphotographic images affects both knowledge and communication at every level.

"Post-photography promises a new image where the real and unreal intermingle," writes Kevin Robins in his article "The Virtual Unconscious in Post-Photography."[4] Photography's deteriorating validity as fact surely isn't a consequence of the mere substitution models provided by computer simulation; it is the result of deep problems in representation itself. The limits of photography, paralleling the limits of language, indicate that formal and self-reflexive models of expression no longer serve the symbolic imperatives of this culture.

One of the central considerations in the emergence of electronic montage is the redefinition of narrative. Sequential or arrayed, information is created in forms that suggest that the single image is not sufficient to serve as a record of an event. . . .

A new range of problems is developing that invokes not merely the formal issues of juxtaposition and association, but those of experience and simultaneity. With technology as a driving force, an aesthetics of technoculture is emerging, which will be linked with telecommunications, narrative, virtual reality, and hypermedia. A language is evolving that must adapt to imagery whose connection to the material world has lapsed, and whose "presence" must be understood discursively. As the conversion from televisual to teleinformational systems becomes feasible, the cultural role of representation is strained to accommodate an accelerated convergence of technology and representation. With the incorporation of scientific visualization, digitally manipulated photographs, and animation that approaches photographic resolution, a boundary has been reached that demands an understanding of images as not only ideological but technological as well.

It is in this environment—with the transformation of media, the initial phases of interactive telecommunication, and the advanced development of computed realities—that art reaches a reinvented relationship with the symbolic. We now have a third phase of montage: electronic montage. In this field, there is total command of everything in the image, a level of control that cannot exist in photography. The constitution of space is discretionary. It is a wholly different way of constructing an image than in painting or photography. Electronic images no longer legitimate the photographic. In fact, they usurp and reconstitute the analog

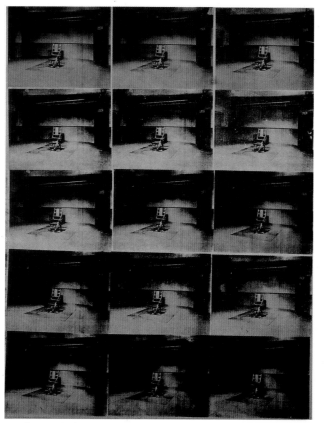

Andy Warhol, *Lavender Disaster*, 1963

as algorithmic; visual order is formulated by a mathematical order. And once the image is digital, it has little to do with photographic systems except by implication. It is in this sense that these images can be called postphotographic, as they no longer rely on the character of the photograph to verify something in the world.

In this lapsed reference system, computed images are not concerned with verification, classification, or any of the systemic epistemologies of the camera. And yet digital information (including images) stands within a hypersystem of surveillance technologies that emerged directly from the military, and are quickly being downloaded to civilian commercial uses. Digital images surround us—from satellite images capable of resolving objects of less than a meter wide to the computer images in cinema that construct

convincing (if exaggerated) Jurassic dinosaurs; to biomedical images of DNA strands; to confounding morphings of form, virtualized identity, and deduced electronic aging. And yet, paradoxically, these electronic images use an uncomfortable version of the logic of photography to confirm them as images. In other words, they are perceptual, but not registered in the optical system of the camera. Objects are not *recorded* in this medium as much as they are *rendered*. One tradition has been inverted in order to construct another.

One of the central considerations in the emergence of electronic montage is the redefinition of narrative. Sequential or arrayed, information is created in forms that suggest that the single image is not sufficient to serve as a record of an event but, rather, that events are themselves complex configurations of experience, intention, and interpretation. Images suggest *transition*, and not resolution. It remains to be seen whether two-dimensional montage will survive the emergence of hypermedia, multimedia, interactivity, and virtual reality. The cultural symbolic space of media is increasingly circumscribed by an uneasy conjunction of powerful symbolic form and accelerated technology.

An extraordinarily broad range of approaches to montage has emerged in the past few years. Accessible technology has afforded a whole generation of artists the opportunity to work with the composing and manipulation tools now commonplace in schools and photolabs. Not surprisingly, the initial efforts turned upon the ability to layer information in electronic space. What is immediately evident is that montage is reemerging as a significant expression of the extraordinary complexity of technoculture, and that it is capable of confronting a range of issues long considered exhausted.

1. Lorraine Daston and Peter Galison, "The Image of Objectivity," *Representations* 40 (Fall 1992), p. 81.

2. The constituted, perhaps intentional, signifier in 1920s advertising, propaganda, and news was to play a decisive role in an emerging image culture, one to be represented by Theodor Adorno and Max Horkheimer as the Culture Industry. But it was the *presence* of the sign rather than an analysis of it that seemed to provoke Dadaist strategies.

3. It should be noted that my discussion in this essay focuses on two-dimensional montage; cinematic montage introduces another entire range of issues related to narrative structure.

4. See *Science as Culture*, no. 14 (v. 3, part 1), 1992, pp. 99–115.

PORTFOLIOS I

COMPUTER PHOTOMONTAGE

EVA SUTTON

BY APPROPRIATING IMAGERY FROM PHOTOGRAPHS (PRIMARILY OLD PRINTS FOUND IN JUNK SHOPS, FLEA MARKETS, AND garbage bins) and combining these images in the computer, I create a kind of visual photomontage. The computer's ability to overlay images, combined with the historical verisimilitude of the photographs, gives the resulting works the aura of relics. This creates a false sense of familiarity and nostalgia. Upon inspection, the gentle, aged appearance of the images gives way to fragile, natural, human elements—hands, faces, and feet—that are usurped by mechanical or technological components. This work is a gathering of cultural fragments—mechanical objects, old tools, gears, illustrations from children's books, photographs—that have been recontextualized to create a metaphorical composite.

Encapsulation #22, 1993 (*above*); *Disintegration #8,* 1991 (*right*)

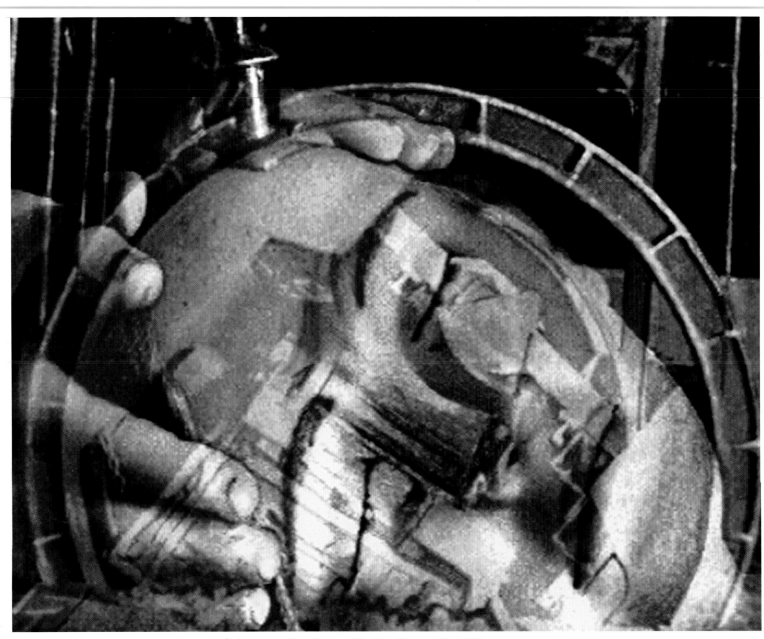

Eva Sutton, *Machine Ecstasy #3*, 1992

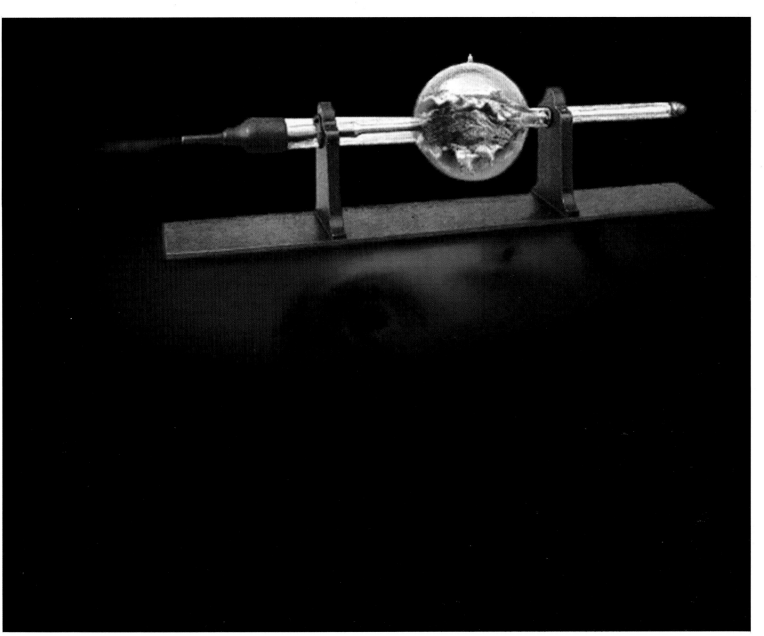

Eva Sutton, *Encapsulation #7*, 1992

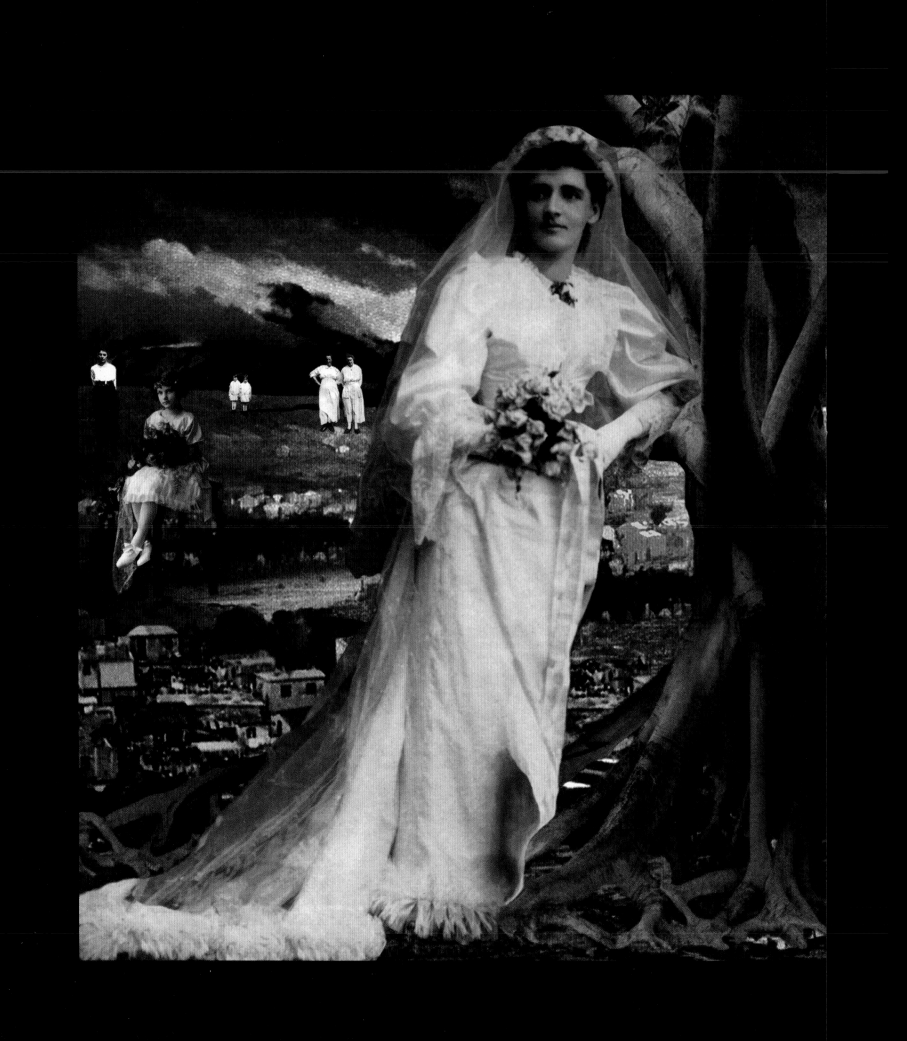

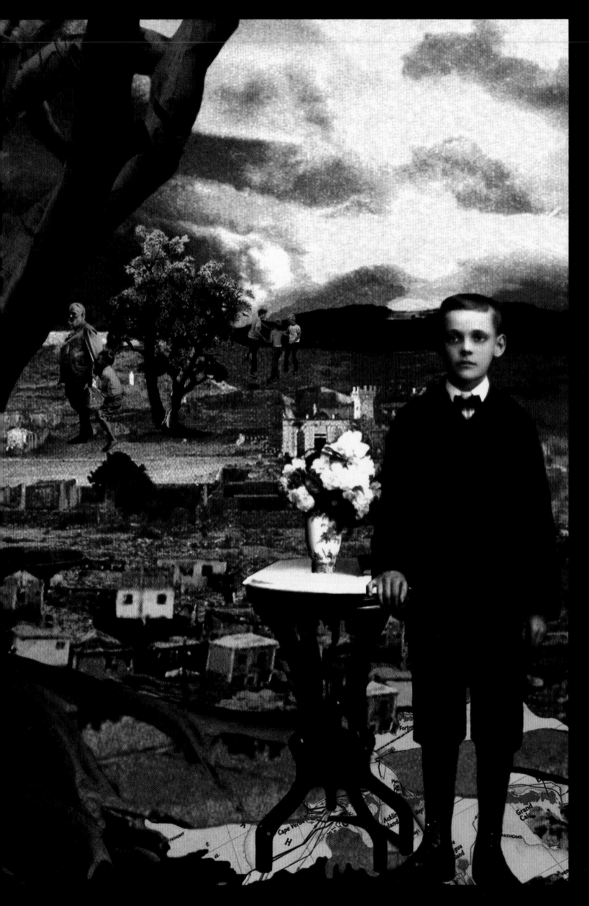

MARTINA LOPEZ

SEVEN YEARS AGO
I BEGAN TO USE
THE COMPUTER TO
CREATE IMAGES THAT
DOCUMENTED MY
OWN FAMILY HISTORY.
I then started to incorporate
family images from beyond
my personal album as a
way to create a collective
history, one that would
allow people to bring their
own memories to my work.

Within these fabricated
landscapes, the horizon
suggests endless time, the
trees demarcate space,
and the fragments of snap-
shots verify an actual lived
experience. The reassembled
figures, their gestures and
expressions, help to create
a story that often reflects
my own personal dreams
and contemplations.

Heirs Come to Pass 4, 1991

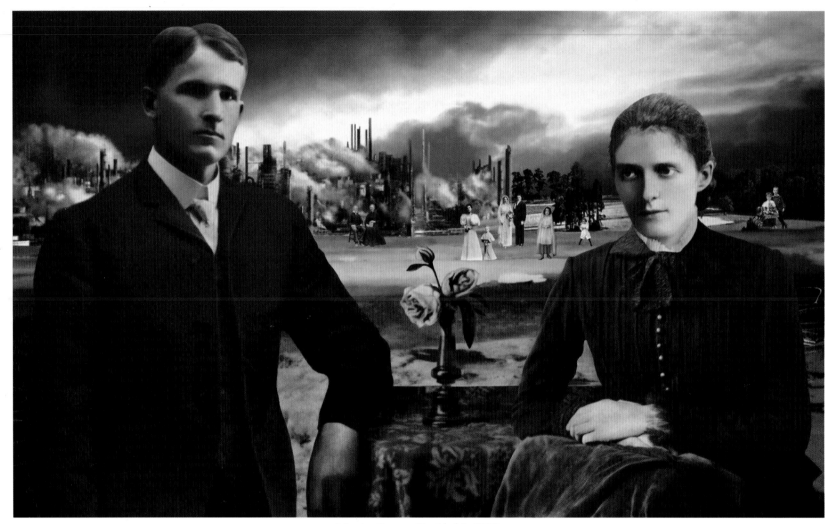

Martina Lopez, *Untitled 2*, 1993

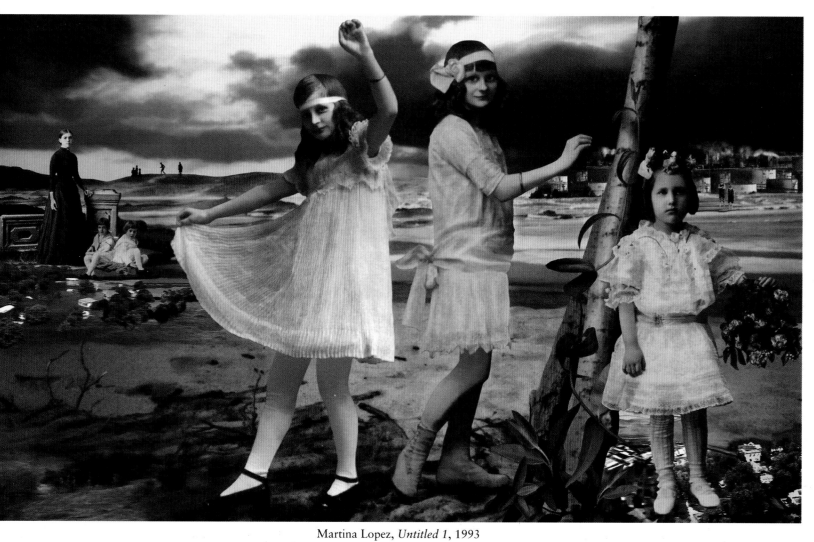

Martina Lopez, *Untitled 1*, 1993

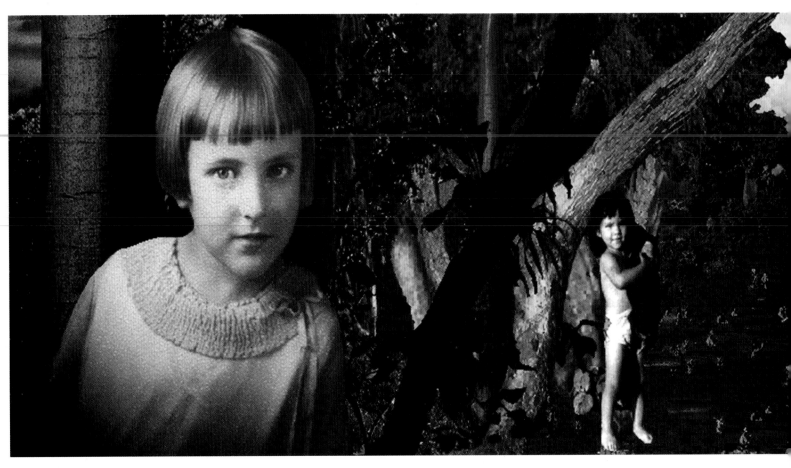

Above: Martina Lopez, *Courting with Time, 2*, 1990

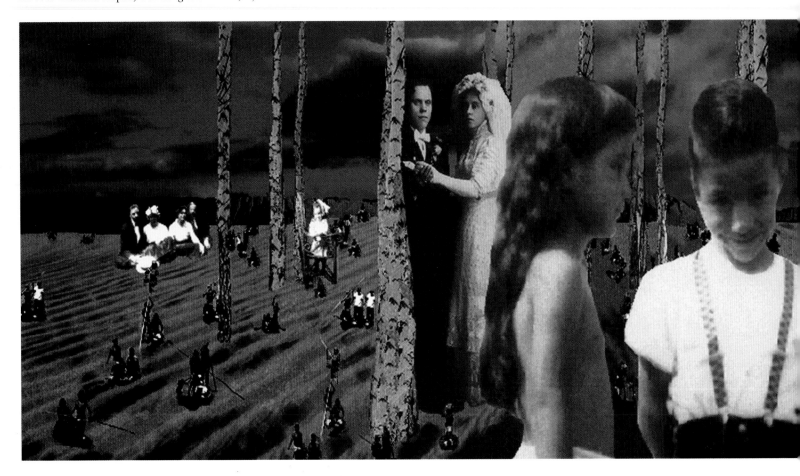

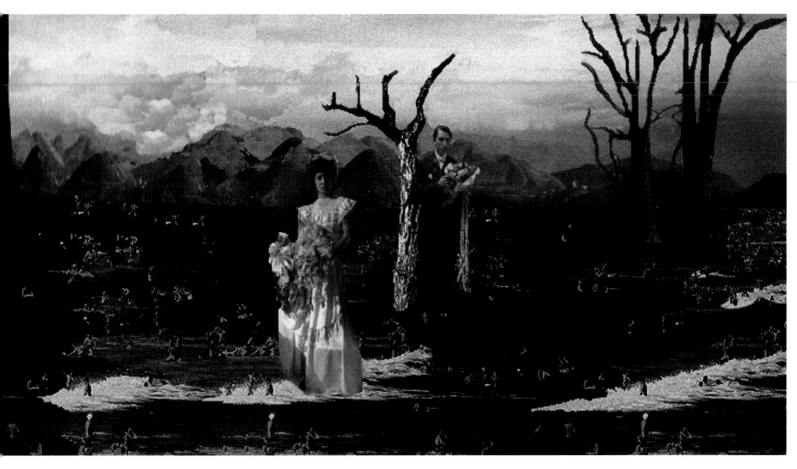

Below: Martina Lopez, *Courting with Time, 3*, 1990

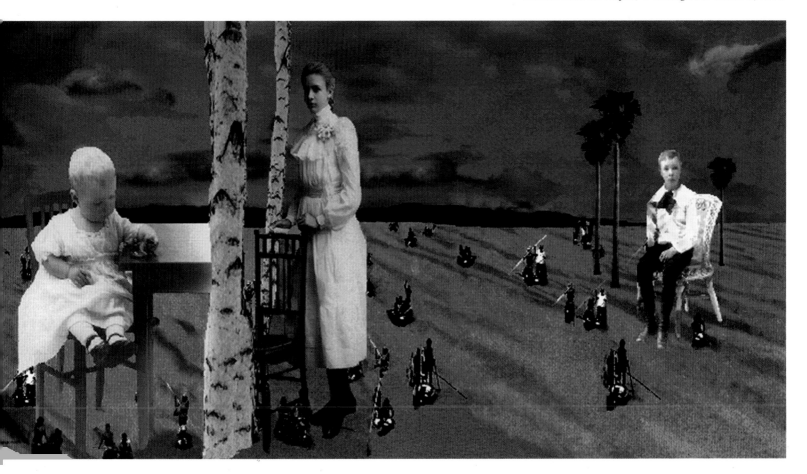

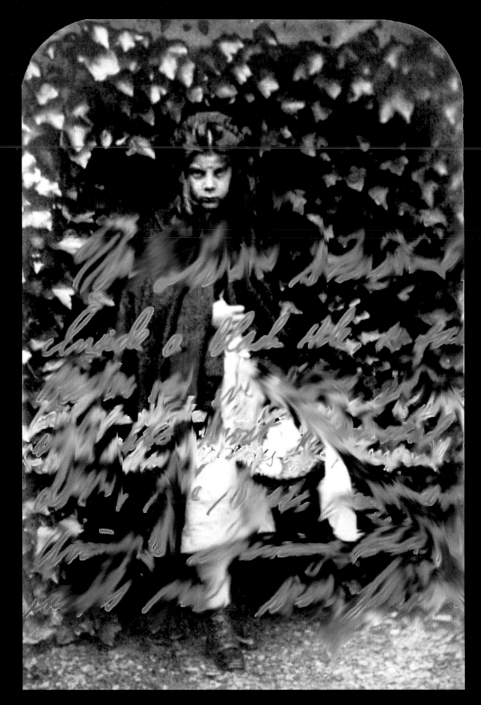

ANIL MELNICK THESE IMAGES DIRECTLY ADDRESS THE RELATIONSHIP BETWEEN TRADITIONAL PHOTOGRAPHY and the digital process. To create them, I digitized and altered photographs that have been canonized by the modernist photographic establishment—images by Ansel Adams, Jacob Riis, Charles Marville, Lewis Carroll, and others that have long been held as examples of the faithful representation of the truth. I believe that through alteration—interrupting the illusion of reality—these images can actually convey truth and emotion in a more direct fashion.

Inside a Black Hole (Carroll), 1993 *The Pen is Mightier (Marville)*, 1993

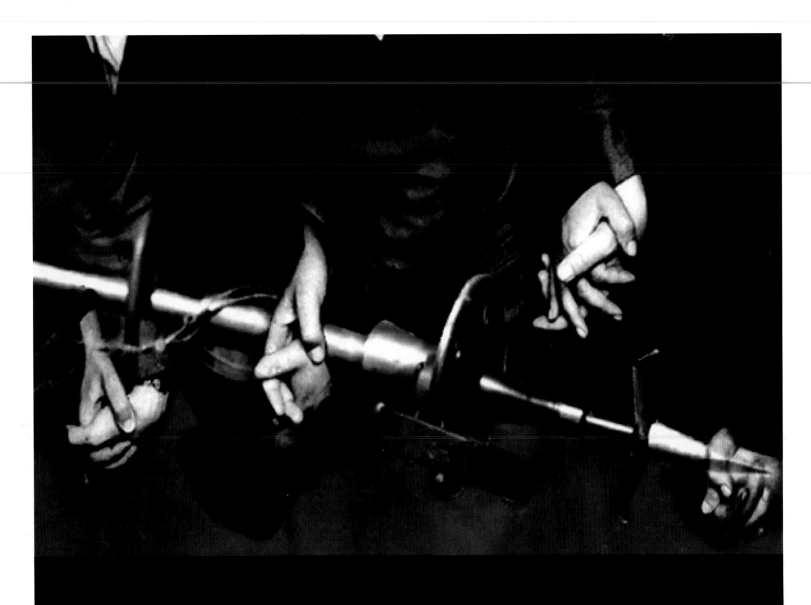

SHELLY J. SMITH

MY WORK
IS BASED ON
IDEAS OF PERSONAL
EXPERIENCE
PRESENTED AS
COMMON GROUND.

I use family archives, historical and personal imagery, as well as found objects that I digitally transform. Using two different computer systems enables me to layer the separate photographic elements with digital precision. Specific pixels can remain opaque or achieve varying degrees of transparency, allowing areas of the picture space to be pulled forward or pushed back. The result is a composite image with one distinctive voice.

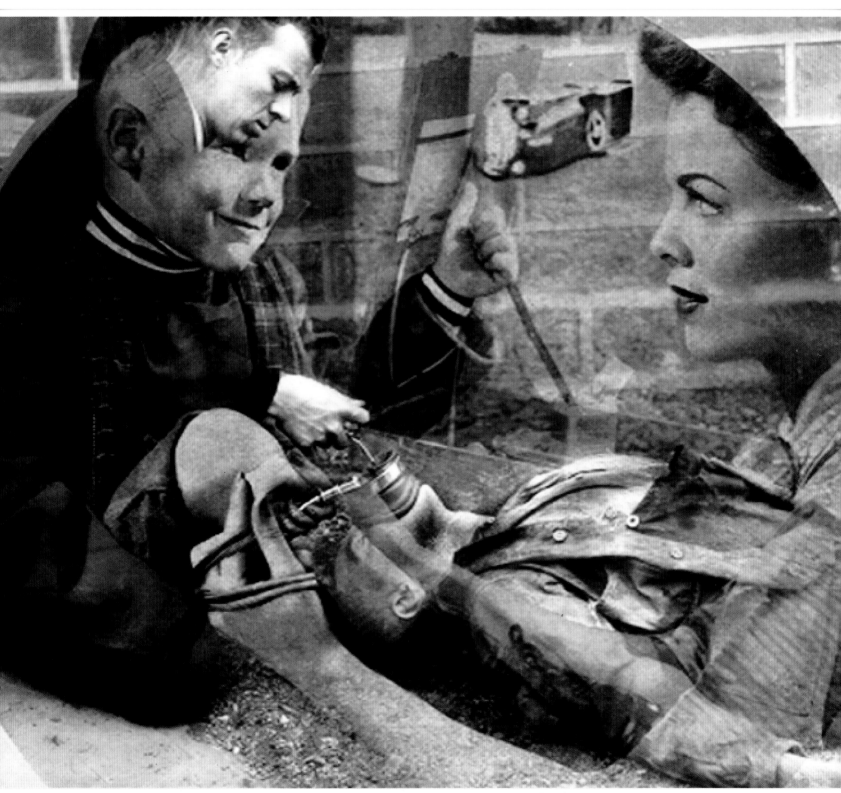

Opposite: Shelly J. Smith, *Untitled Gun 2*, 1991

Above: Shelly J. Smith, *Untitled Carreck*, 1992

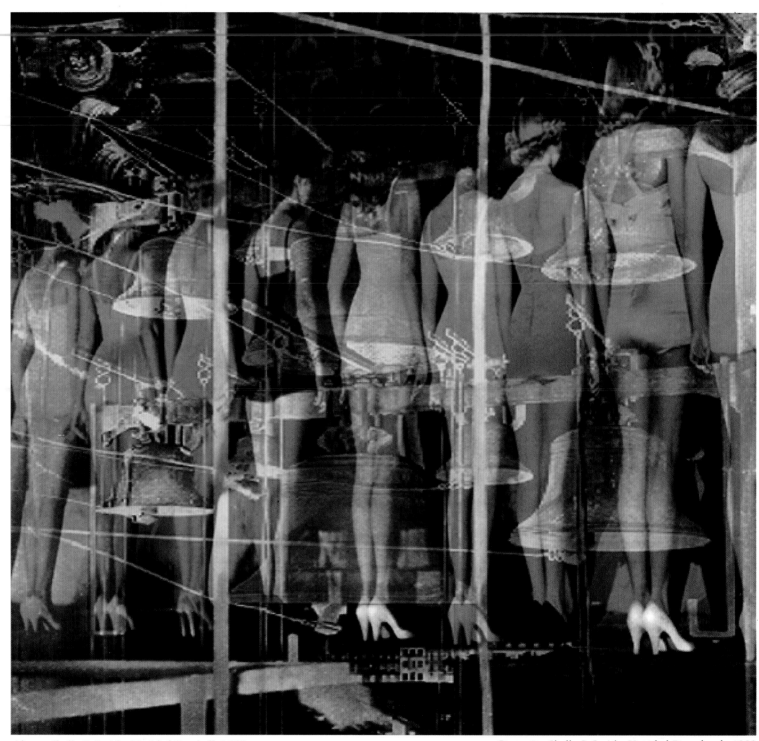

Above: Shelly J. Smith, *Untitled Beatbell*, 1992 *Opposite*: Shelly J. Smith, *Untitled Dresshook*, 1992

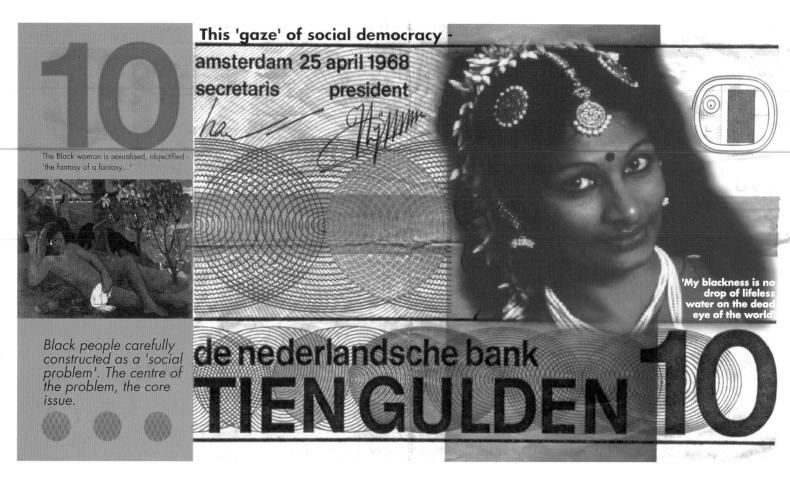

The following text appears within the upper image:

This 'gaze' of social democracy -

amsterdam 25 april 1968
secretaris president

10

The Black woman is sexualised, objectified -
'the fantasy of a fantasy...'

Black people carefully constructed as a 'social problem'. The centre of the problem, the core issue.

de nederlandsche bank

TIEN GULDEN 10

'My blackness is no drop of lifeless water on the dead eye of the world'

Roshini Kempadoo, all images from the series "ECU—European Currency Unfolds," 1992

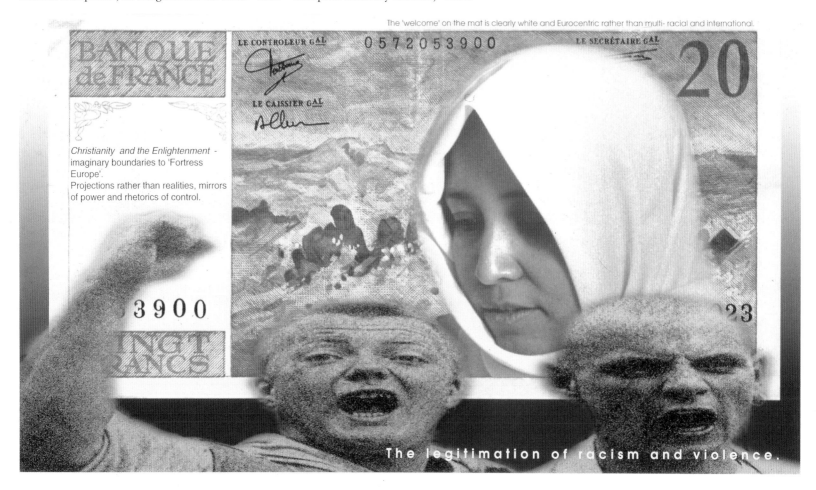

The following text appears within the lower image:

The 'welcome' on the mat is clearly white and Eurocentric rather than multi- racial and international.

BANQUE de FRANCE

LE CONTROLEUR GAL 0572053900 LE SECRÉTAIRE GAL

LE CAISSIER GAL

20

Christianity and the Enlightenment - imaginary boundaries to 'Fortress Europe'.
Projections rather than realities, mirrors of power and rhetorics of control.

VINGT FRANCS

The legitimation of racism and violence.

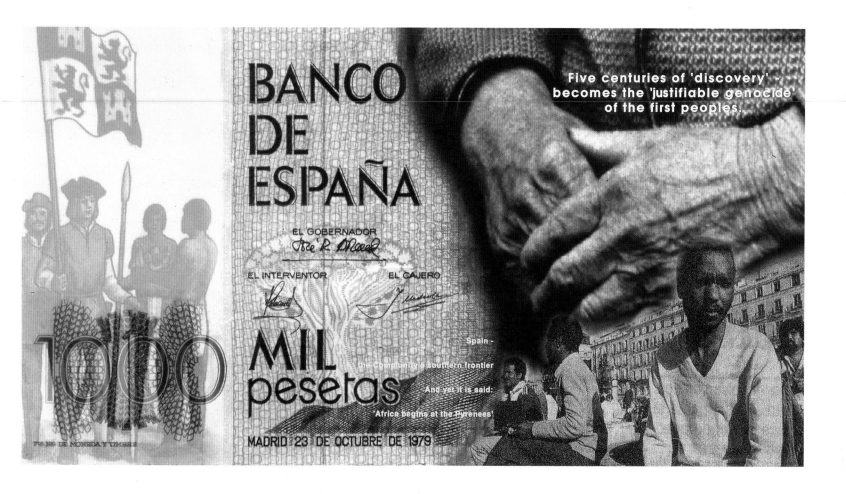

Five centuries of 'discovery' -
becomes the 'justifiable genocide'
of the first peoples.

Spain -
the Community's southern frontier

And yet it is said:

'Africa begins at the Pyrenees'

ROSHINI KEMPADOO

THIS WORK IS CONCERNED WITH THE INCREASED THREAT TO BLACK COMMUNI-
TIES IN EUROPE AS THE CONTINENT IS BEING ECONOMICALLY AND CULTURALLY
REDEFINED AS THE EUROPEAN UNION. THE FABRIC OF SOCIETY AS A CHEAPER
work force, blacks in Europe are not given equal status—are still considered "foreigners" or
immigrants. Requests for aid by Third World nations exploited by years of colonial oppression are overshadowed by the political demands of new Eastern European states. The reformulation of European identity is resulting in the subsequent regrouping of old communities, often established at the expense of new arrivals.

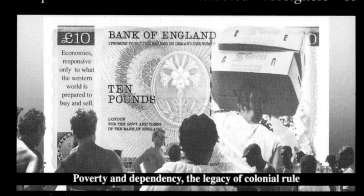

Poverty and dependency, the legacy of colonial rule

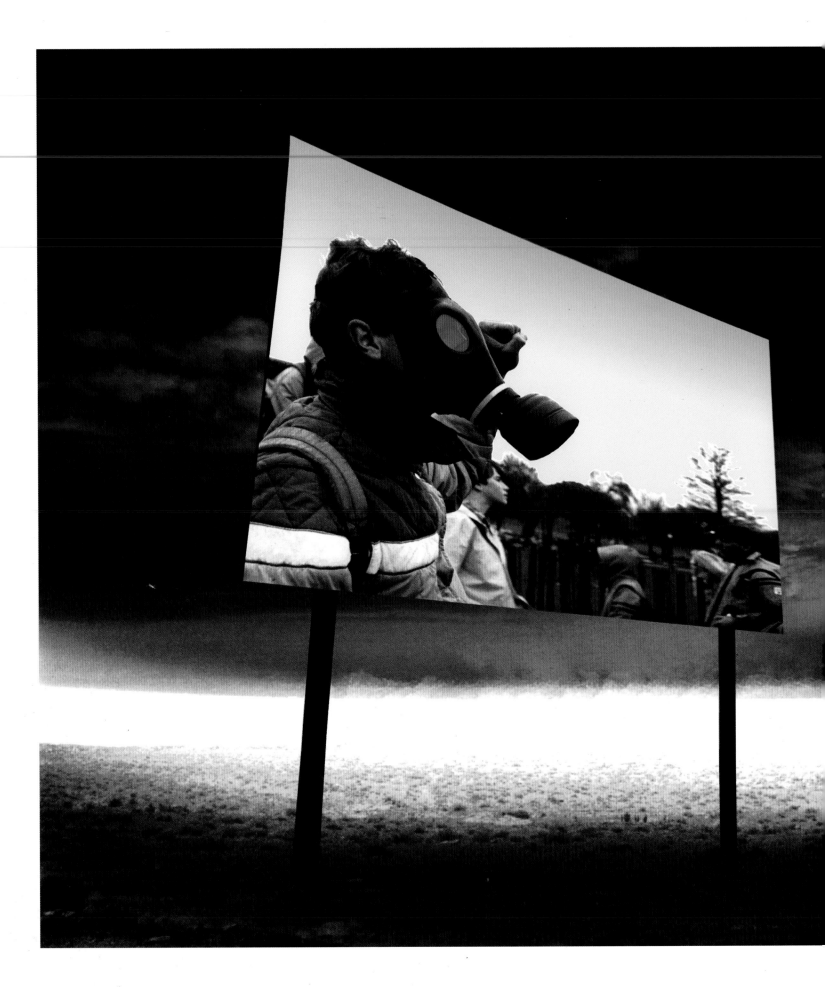

OSAMU JAMES NAKAGAWA

I WAS BORN IN THE UNITED STATES, BUT MUCH OF MY LIFE HAS BEEN DIVIDED BETWEEN JAPAN AND AMERICA. AS A RESULT, I feel a stranger to both Japanese and English. Photography has become my expressive bridge.

The "Drive-in Theater / Billboard" series uses the idea of a frame within a frame. I paste images I have photographed—which in my view represent some aspect of American culture—onto drive-in movie screens and billboards. Though the drive-ins are abandoned and decaying, images still appear on screen. The nostalgic mythology of the drive-in theater is juxtaposed with explicitly public and political messages. Similarly, the commercial nature of the billboard is subverted. The series as a whole proposes a critical inspection of Western society from my particular viewpoint, which is Eastern in origin and Western by immersion.

Gas Mask, from the "Billboard" series, 1993

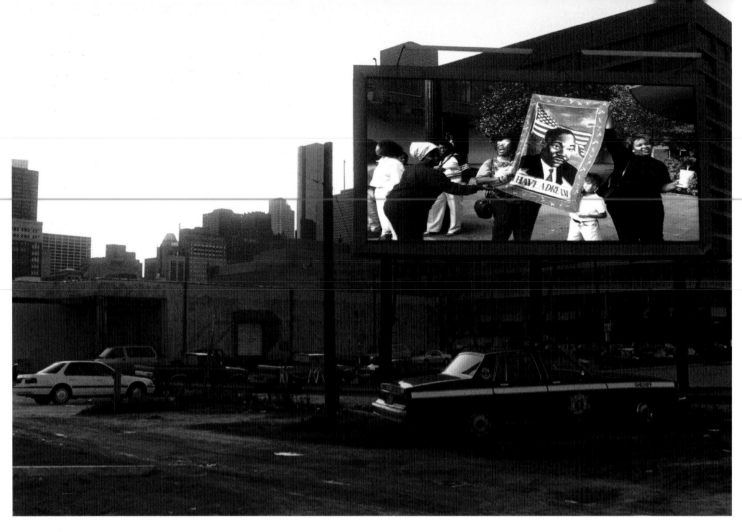

Osamu James Nakagawa, *Martin Luther King*, from the "Billboard" series, 1993; *below*: *McDonald's*, from the "Billboard" series, 1993

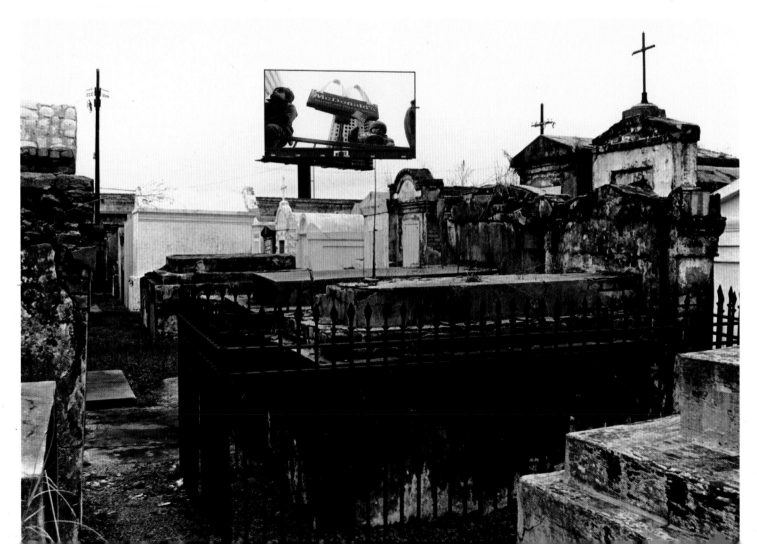

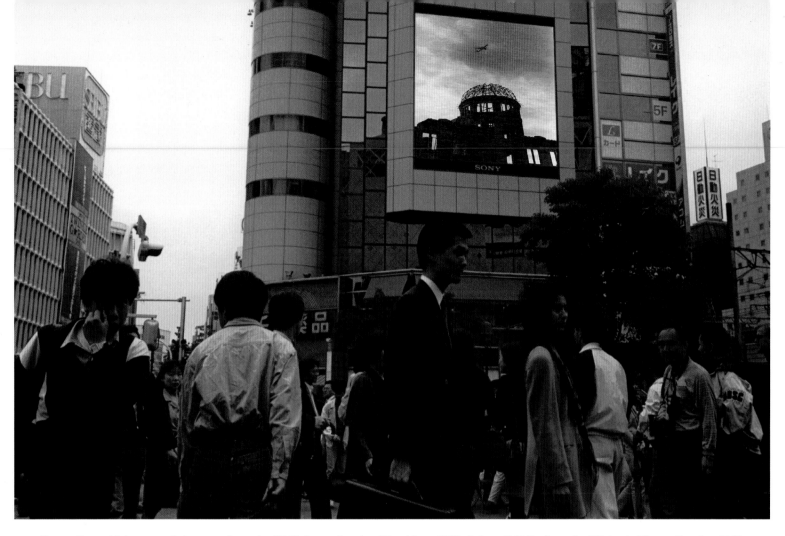

Osamu James Nakagawa, *Point-zero*, from the "T.V. Screen" series, Hiroshima, 1993; *below*: *K.K.K.*, from the "Drive-in Theater" series, 1992

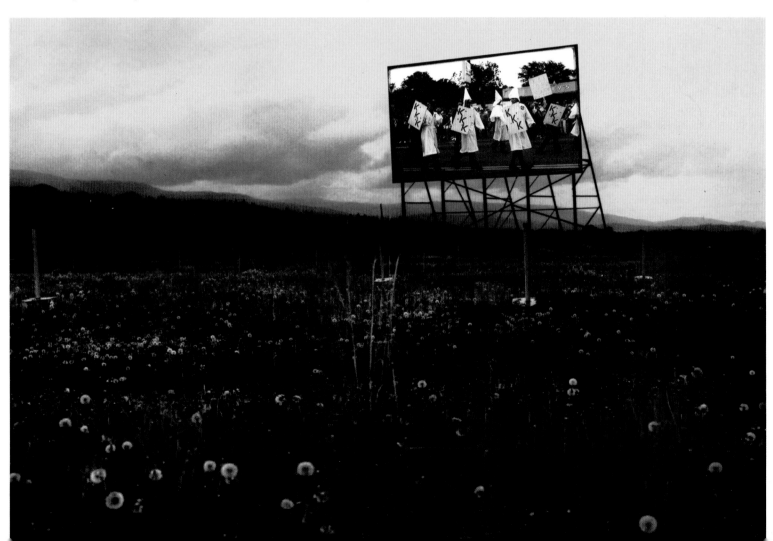

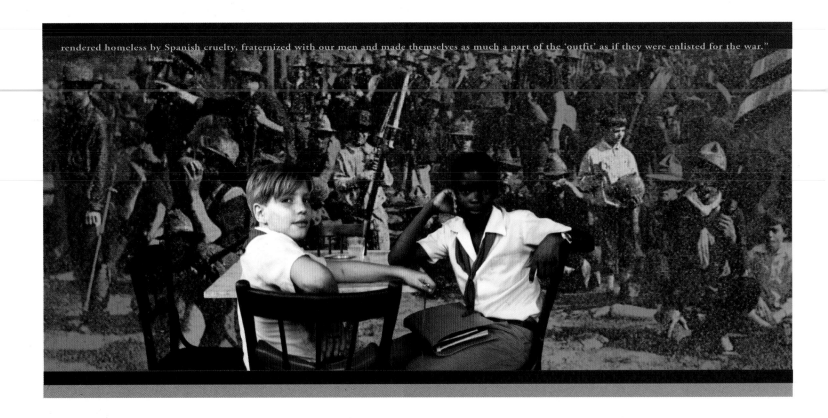

rendered homeless by Spanish cruelty, fraternized with our men and made themselves as much a part of the 'outfit' as if they were enlisted for the war."

ESTHER PARADA BOTH OF THE WORKS REPRODUCED HERE ARE PART OF THE SERIES "2–3–4–D: DIGITAL REVISIONS IN TIME AND SPACE," IN WHICH I USE DIGITAL TECHNOLOGY TO CHALLENGE AND COMPLICATE HISTORICAL STEREOTYPES.

At the Margin is a response to the ubiquitous image of Christopher Columbus (as New World "discoverer") in Latin America. The four-panel sequence progressively subverts a 1939 vintage stereograph of the Columbus monument in the city of Trujillo, Dominican Republic, by moving the figures who are literally and symbolically marginalized (the black woman at the edge of the frame and the Indian woman at the base of the statue) to the center.

Friends and Deliverers, while based on the image of U.S. soldiers in Cuba at the time of the Spanish-American War, reflects on an ongoing pattern of U.S. invasion of Third World countries, rationalized as democratic salvation from demonic Old World or Communist forces.

In both sequences, by montaging uniformed figures of Young Pioneers from contemporary Cuba with the historical images, I celebrate the militant pride and interracial fraternity of this revolutionary social order, while at the same time suggesting its potential for regimentation.

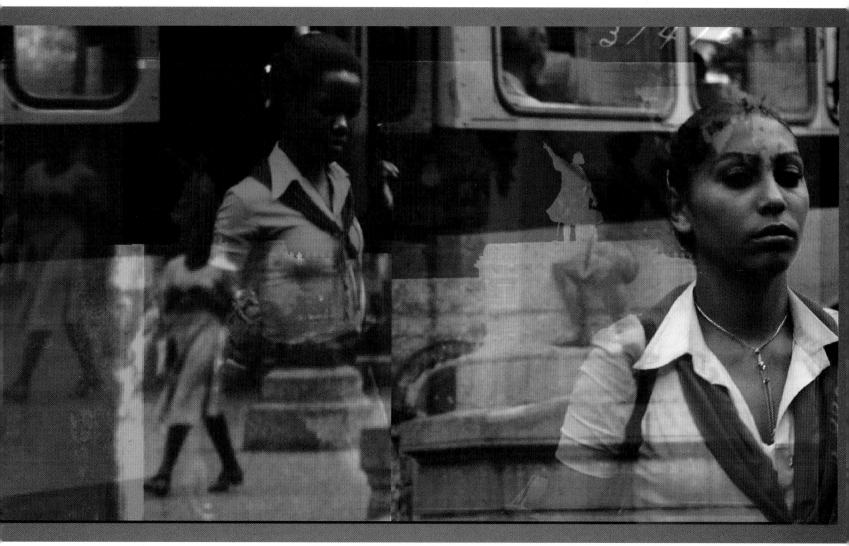

Esther Parada, *At the Margin*, panel 4 of 4, from "The Christopher Columbus Sequence of 2-3-4-D: Digital Revisions in Time and Space," 1991–92

Opposite: *Friends and Deliverers*, panel 2 of 2, from "The Christopher Columbus Sequence of 2-3-4-D: Digital Revisions in Time and Space," 1992

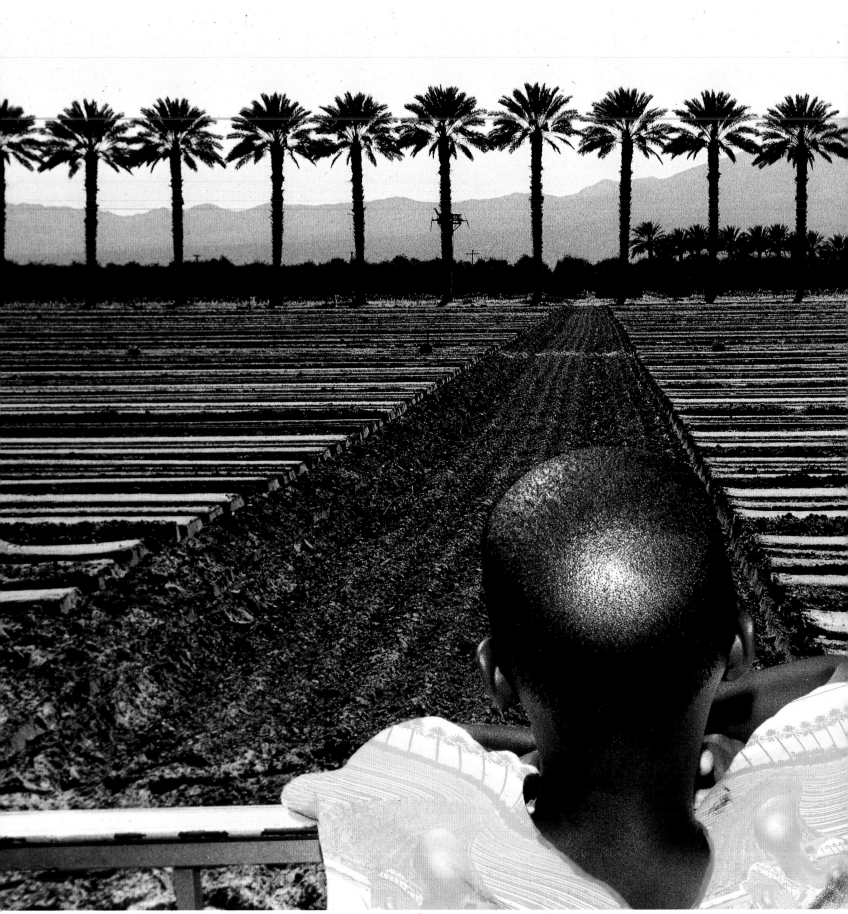

Pedro Meyer, *Plantación* (Plantation), El Centro, California, 1987/92

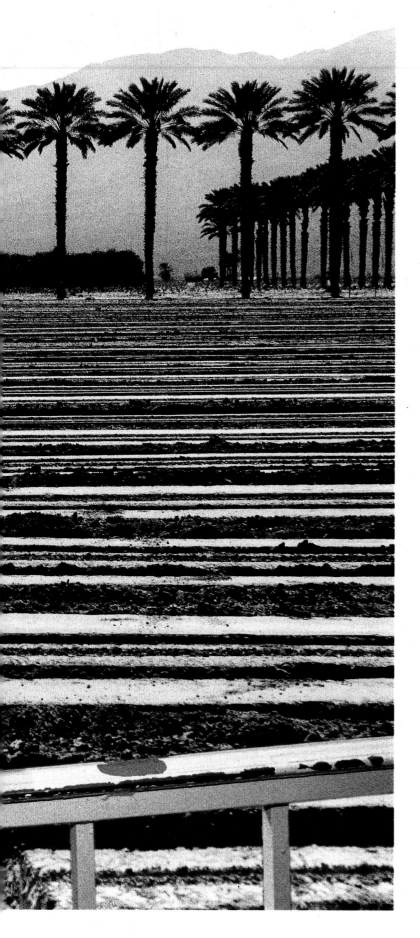

PEDRO MEYER'S DOCUMENTARY FICTIONS

BY JONATHAN GREEN

"Photographic reality" is an expression that has defined our notion of visual truth for the past 150 years. Pedro Meyer's new digital photographs call into question this long-lived concept. His wry images challenge the essential truths and myths surrounding the documentary aesthetic. They show that photographic images can be edited and transformed with the same ease with which sentences can be moved and altered on a word processor. Meyer's pictures highlight the transition of the photographic medium from its photochemical origins to its new electronic foundation.

In contrast to images that announce their synthetic nature—such as Jerry Uelsmann's surreal combination prints, Oscar Rejlander's historical melodramas, or even Joel-Peter Witkin's improbable people in impossible settings—Meyer's images show us the world from the perspective of traditional documentary and street photography. They seduce us with real evidence, pictorial facts, visual puns, ironic juxtapositions, and political narratives.

Photographers have always known that the "straight" photograph is actually highly contrived and subjective, reflecting their own psyches, as well as the aesthetic, political, and commercial demands of the moment. Yet, for well over a century, there has been an unspoken covenant between photographer and audience, an agreement to embrace the myth of photographic truth. Meyer's digital photographs shatter this covenant. He is perversely comfortable reprocessing discrete bits of photographic information into new photographic "facts" in order to make his point.

In a number of his recent social and political investigations, Meyer focuses on the stereotypes surrounding Mexicans in the United States. In *Mexican Serenade*, for instance, a miniature ceramic mariachi band becomes a yard ornament at a trailer park. But Meyer employs his digital wit to turn the tables on this type of diminishing caricature by reducing the Anglo trailer owner to pint-size as well.

More caustically, and tragically, Mexican migrant workers in another image perform stoop labor under the largesse of a Caesar's Palace sign that proclaims "Free luxury service for all." The current tyranny, American capitalism, has rendered unto Caesar a new contingent of agricultural slaves. As we find in many of Meyer's photographs, the seriousness of his message is presented with tragicomic counterpoint. Using the precise controls offered by the digital medium, he presents us with a series of provocative, often humorous fables and wry social observations that use irony and wit to bring the truth home.

Plantation, El Centro is one of Meyer's subtlest yet most powerful photographs of minorities in the United States. On careful viewing, this photograph of a black child reveals—burned onto the

child's head and back, as though he had been run over and embossed by a tire's tread—an image of the row upon row of crops through which he has toiled; the plantation has now totally usurped his mind and psyche.

These constructed photographs call to mind the biting political commentary of photomontage. Yet photomontage made its point by unexpected juxtapositions and discontinuous images. Meyer jolts our consciousness by presenting a continuous, almost believable world. In these scenes he uses the computer to synthesize multiple elements into a single, seamless image—to highlight the plight of black and Mexican workers, to exaggerate the discrepancies of wealth and poverty, and to create ironic and humorous juxtapositions that describe actual social conditions. Digital photography is used as a political weapon to cry out against injustice and inequality.

Meyer's American work is directly related to the American documentary tradition—particularly to the photography of another outsider, the Swiss photographer Robert Frank. Meyer crosses Frank's biting, expressionistic work with visual jokes and fables in the vein of Garry Winogrand. Like the work of both of these predecessors, Meyer's photographs are a careful examination of the American character and psyche. Looking at this country through the eyes of an outsider, he is unwilling to buy into the mythology of the West or to believe the Horatio Alger stories of wealth and success. He looks at America from a grand, tragicomic perspective, showing a land that subverts and distorts

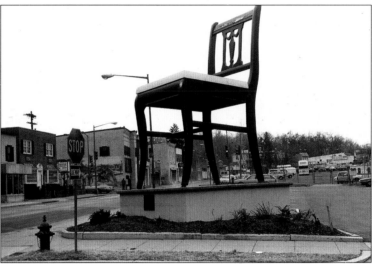

Silla Monumental (Monumental chair), Washington, D.C., 1989

traditional and classical values. Meyer's photography of America reveals barrenness, alienation, and desperation: vulgar and pathetic realizations of the American Dream.

Sometimes Meyer craftily introduces a straight photograph in a series of altered ones. His *Monumental Chair*, Washington, D.C., 1989, for example, is a play on scale that looks more obviously altered than most of his digital photographs. However, the alteration took place in the landscape itself; Meyer simply made a documentary photograph of a giant piece of American kitsch.

Though the viewer never knows for certain whether any given image is straight or altered, all of Meyer's American work possesses the integrity and coherence of a single, finely seen photographic moment. Even if the elements in a given image were taken years and miles apart, the image functions socially and psychologically as a traditional documentary photograph. Henri Cartier-Bresson's "decisive moment" has been reinvented as the *digital* moment, a seamless presentation of constellations of separate, singular occurrences brought together into a coherent, seemingly "photographic" whole.

Meyer's recent work looks both north and south, toward the United States and toward Mexico. While his vision of the United States hovers on the edge of a nightmare of exploitation and spiritual poverty, his vision of Mexico—a vision that concentrates on the Mixtec people of Oaxaca—hovers on the edge of a wondrous dream. The first indication of the sea change that takes place as we move from north to south is the change in the medium itself: a cold black-and-white world gives way to color. This is a world of remarkable visual richness, bright color, and floating figures. It is a world where one constantly experiences the extraordinary within the ordinary. Transformation, in the Catholic sense of eucharistic transubstantiation, is always possible.

It is significant that Meyer's alterations of the straight image are much subtler in the photographs of the United States. The commentaries he wishes to make about the American scene are so plainly evident that only very slight alterations are needed to intensify and refine the message. In the images from Oaxaca, on the other hand, Meyer's interventions are much more aggressive. Here, rather than working with the superficial, he is trying to bring into the visual spectrum aspects of spirit and emotion that lie beyond the surface. He is attempting to see what the eye cannot normally see.

Meyer's work from the United States and from Oaxaca would not have been possible without the computer's capacity for smooth alteration and amalgamation. Yet, in spite of the photographer's interventions, these images cannot be classified as synthetic media. They are not paintings or drawings. They remain essentially photographic. They draw their strength from a direct relationship to "photographic reality," that surface world of reflected light that the camera has so precisely described throughout its history. Meyer's photographs usher in a new reality: a brave new world of *digital* rather than *visual* truth. Here, image makers will take us into the postphotographic era, in which new forms of visual rendering will reveal extraphotographic reality. Meyer warns us that the computer has the potential for abuse as well as delight. But in his hands it has opened up new vistas: it shows us a visual world about which authors have written and poets have sung. It is a world that up until now has eluded the camera's eye.

This essay was adapted from spoken commentary by Jonathan Green for Pedro Meyer's CD-ROM, entitled "Truths & Fictions: A Journey from Documentary to Digital Photography," which is available from Voyager, in New York City. A book of Meyer's digital photographs will be published by Aperture in the spring of 1995.

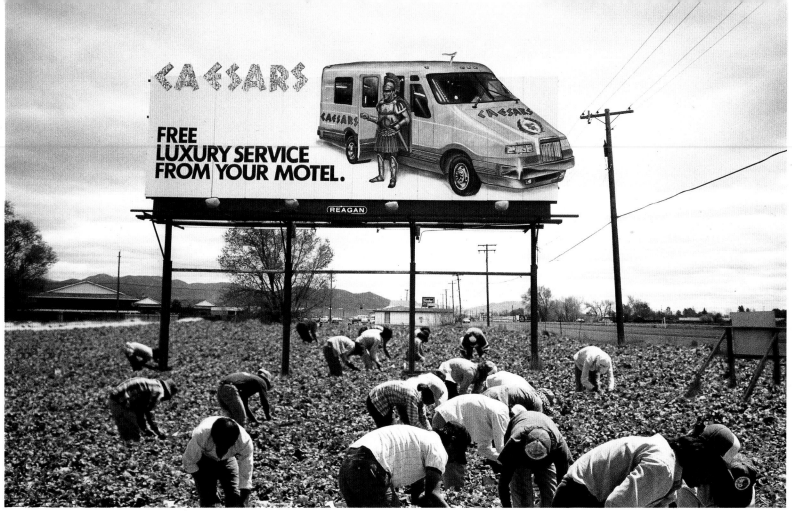

Above: Pedro Meyer, *Trabajadores Migratorios Mexicanos* (Mexican migrant workers), California, 1992

Below: Pedro Meyer, *Serenata Mexicana* (Mexican serenade), Yuma, Arizona, 1985/92

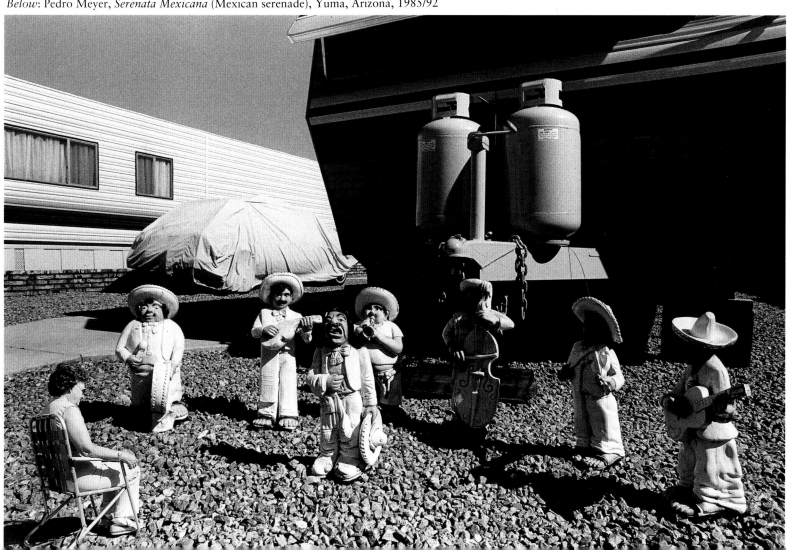

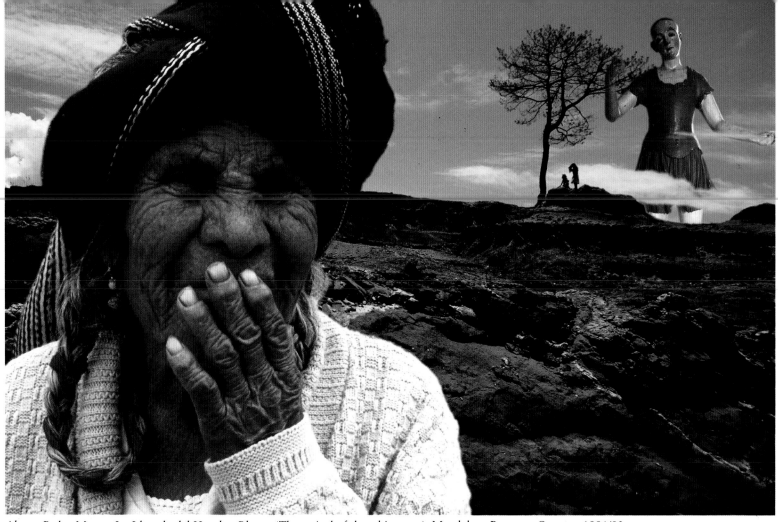

Above: Pedro Meyer, *La Llegada del Hombre Blanco* (The arrival of the white man), Magdalena Penazco, Oaxaca, 1991/92

Below: Pedro Meyer, *El Santo de Paseo* (The strolling saint), 1991/92

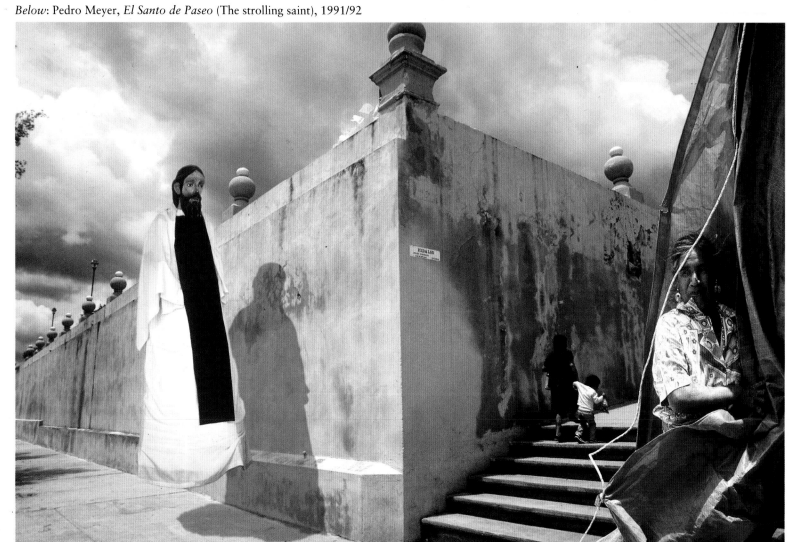

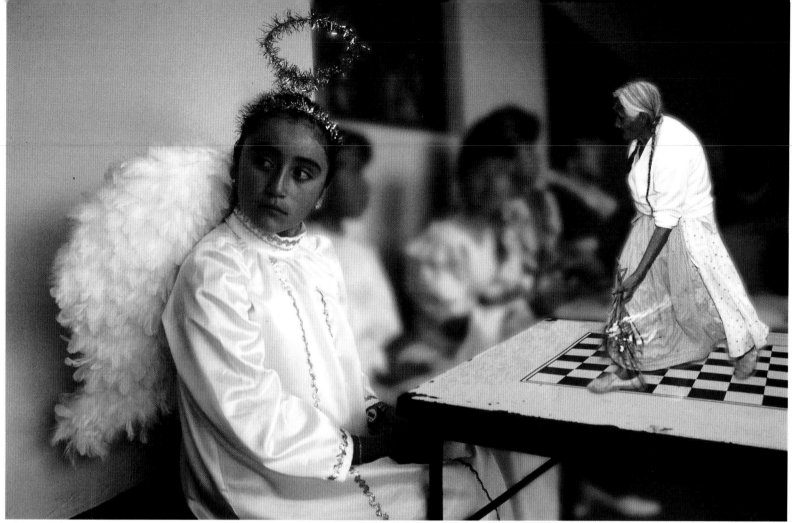

Above: Pedro Meyer, *La Tentación del Angel* (The temptation of the angel), 1991

Below: Pedro Meyer, *El Caso del Cuadro Faltante en el Retablo* (The case of the missing painting from the altarpiece), Yanhuitlan, Oaxaca, 1991/93

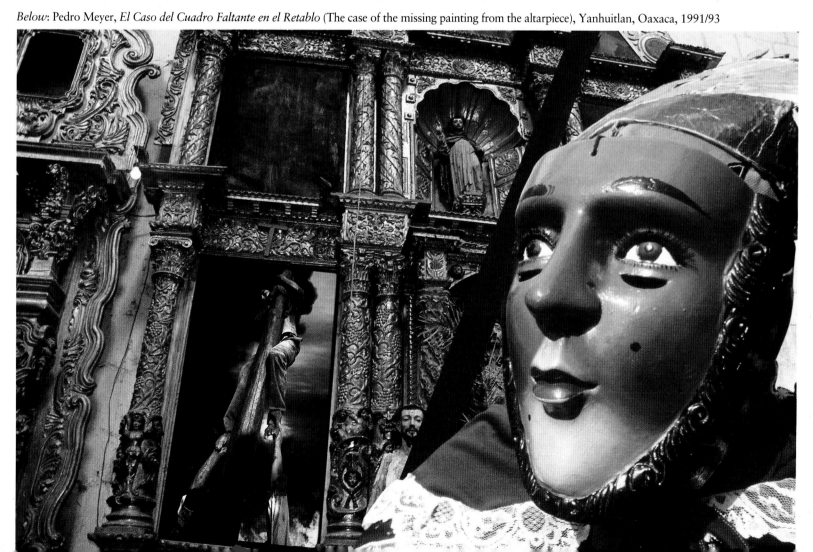

WILD IRISES

A Nash Editions Portfolio

BY VINCENT KATZ

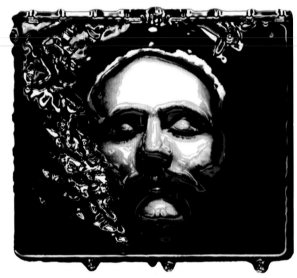

Graham Nash, *Chrome Magnum*, 1991

Graham Nash is a man of many interests. He is probably best known as the soft, dreamy voice in the rock group Crosby, Stills and Nash. His previous band, the Hollies, rattled off a string of hits in the 1960s with a decidedly English feel, different from CSN's down-home, radical American hippie sound. Further in, Nash is the Manchester-born son of an amateur photographer, who fell in love with the art when he was very young, helping his dad tack up a blanket over a window to create an impromptu darkroom.

After Nash achieved musical success, he began amassing one of the most prodigious collections of photography in the world. Never limited to a period or school, Nash is fascinated by the medium as a whole, from its tentative beginnings to the latest experimentation. When Nash put some 2,400 photos from his collection up for sale at Sotheby's in 1990, almost every important photographer was represented. But the sale, which brought in $2.17 million, raised questions: Had Nash created this collection simply as an investment? Was he just a very shrewd speculator who had realized photography's under-tapped market potential, turning millions into more millions? In fact, this was not the case. Nash had sold his collection, which he cherished dearly, to finance another project, even closer to his heart. He started Nash Editions in Manhattan Beach, outside of Los Angeles, with friend and former CSN road manager, Mac Holbert, to initiate a high-quality digital screening and printing studio.

Part of Nash Editions' mission is to create an environment where artists feel comfortable experimenting with this new technology. There are two basic techniques that can be applied. The scanner can turn an existing image into digital information, from which a print can be produced of up to three by four feet, with remarkable richness of tone, and none of the graininess that occurs in normal photographic enlargement. The blacks are pure rich blacks, the grays pure grays. The delicacy of the entire print is comparable to that of a lithograph or a gravure. The other, and perhaps even more exciting, aspect to the new technology is the well-known capability of manipulating digital information.

Once an image has been translated into digital, the artist can rearrange, add, discard, mutate, bend, and color it at will.

Nash and Holbert started with an Apple Macintosh II, a Truvell scanner, and a program called Photoshop. Although Nash relished the opportunity to experiment on-screen (he is also a digital music afficionado), he was dissatisfied with the printed results, and began to seek out better machinery. Finally, he came across a color ink-jet printer from Iris Graphics, and he found the quality of the prints amazing. The printer sprays ink through infinitesimal openings onto paper attached to a rotating cylinder; there is no actual contact with the paper itself—it is in fact possible to print onto any surface. But even this extraordinary (and very costly) printer has its drawbacks. Designed for color proofing, the inks tend to fade rapidly, and black-and-white capabilities are not equal to the color results. At Nash, a computer programmer was able to adjust the black-and-white levels, and water-based inks resulted in prints that will hold up, it is estimated, for a minimum of twenty years. Nash expects that they will soon achieve the permanence of archival prints. "The most exciting thing we're working on," he says, "is the stability of the inks. We've been saying for some time, 'You give us stable ink, and this business will be blown wide open.'"

Having purchased the Iris 3047 Graphics printer, Nash Editions brought in Jack Duganne to be their master printer. They wanted to create an atelier, a place where this new graphic opportunity could be expanded by those best equipped to do so—artists. Early on, publisher Raymond Foye was instrumental in introducing Nash to Francesco Clemente and David Hockney. According to Nash, these two artists "always saw it as a new medium, embraced it immediately, and just incorporated it into their own mode of expression." David Byrne and Allen Ginsberg have also worked with Nash Editions, and the company continues to grow.

Robert Heinecken, *Vacation*, 1991

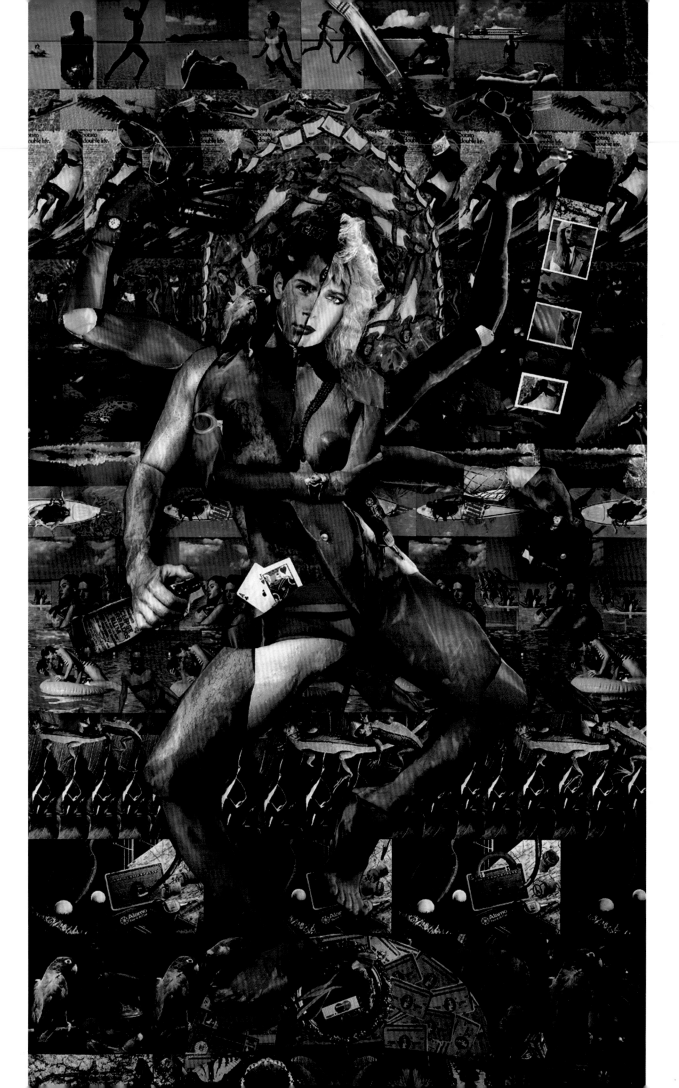

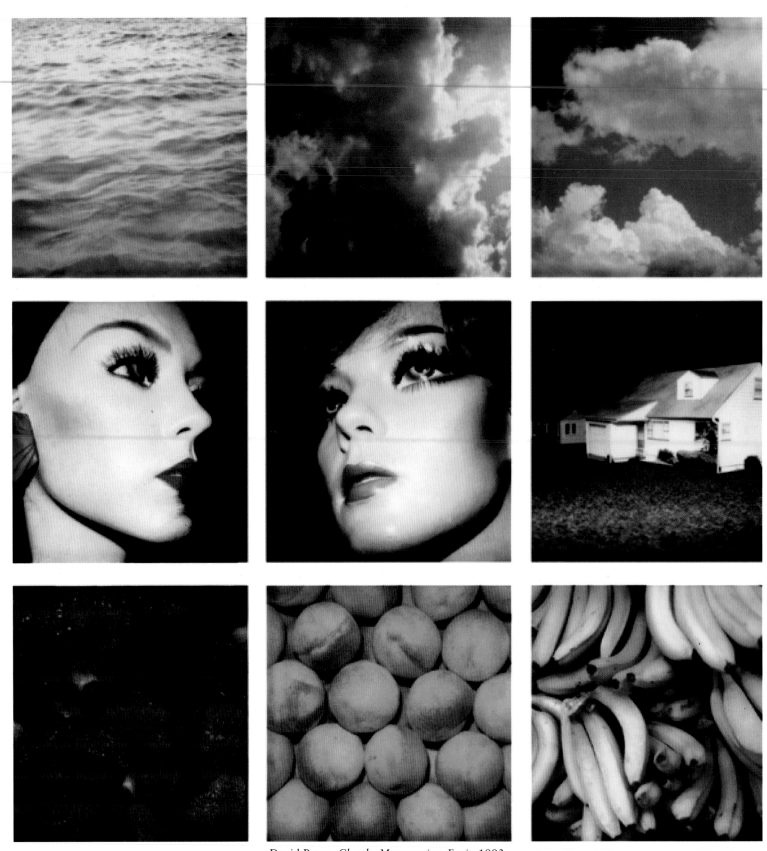

David Byrne, *Clouds, Mannequins, Fruit*, 1993

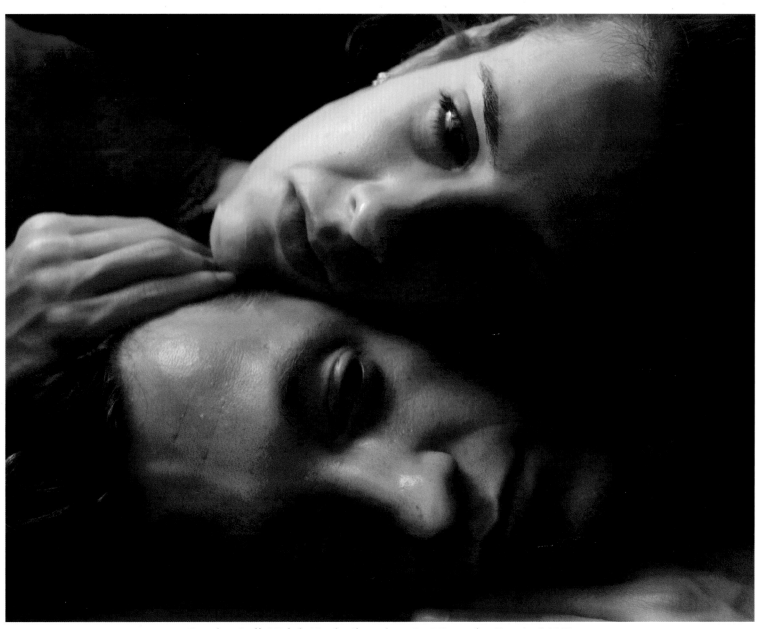

Jonathan Reff, *Michele Nicolas*, from the series "Cameraless Portaits," 1992

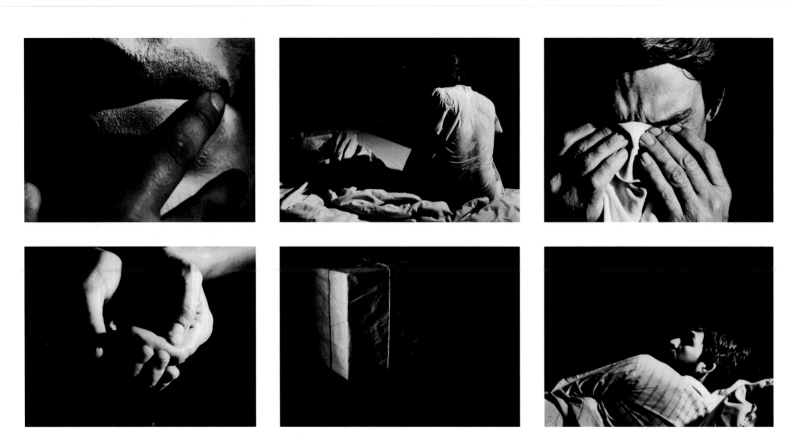

Eileen Cowin, *Based on a True Story*, 1993

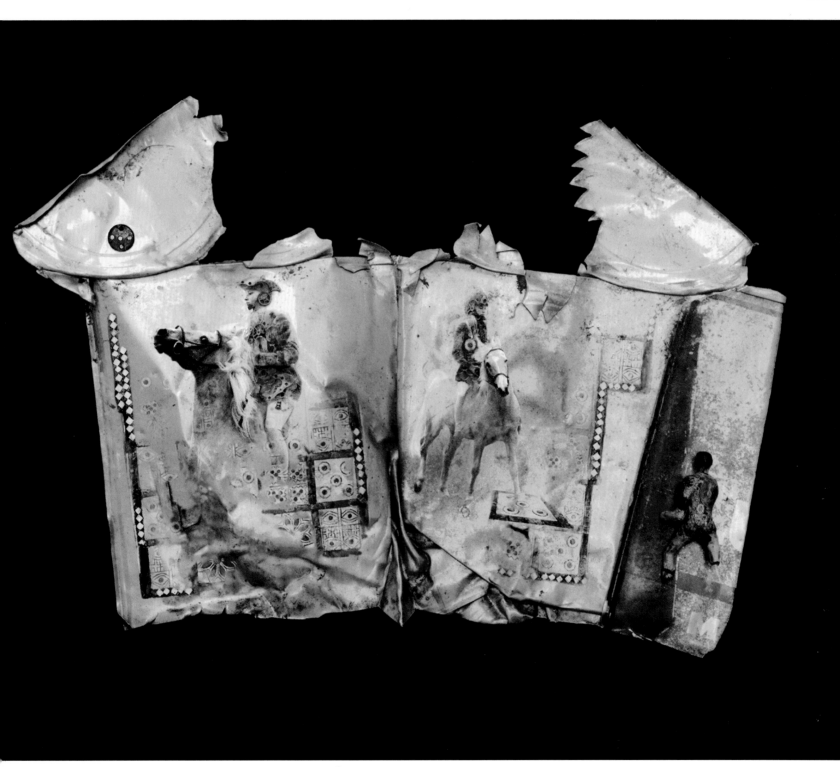

Olivia Parker, *Horseplay*, 1993

Some artists are content to scan their own existing images and to work with the system's wonderful printing capabilities; others are more intrigued by the possibility of computer manipulation. Robert Heinecken has created a powerful icon in his unique photo-collage, *Vacation*, which measures an imposing seven by four feet. The Nash *Vacation* is composed of four sheets, and although it is of course flat—not collaged in texture—the intricacy in detail and the color balance of this postmodern take on the Hindu god Shiva are breathtaking. Heinecken's interest has not been in the manipulative side of Nash Editions, but in reproduction: "I'm not involved in the computer. I generate these things by hand; they're collage pieces. All I'm using the technology for is to get from that original matrix to a print. I've always used lithography and etching in that way."

But the ability to produce reliably perfect images, time after time, should not be discounted. Heinecken explains, "There are precise ways you can lighten, darken, change hue....In the case of *Vacation*, perhaps the colors are a little brighter or more saturated than they are in the original piece. It's very simple to proof; you can make any subtle shift you want in any of the four colors [cyan, magenta, yellow, black]."

Eileen Cowin has done two pieces with Nash Editions, both, like Heinecken's, to reproduce existing imagery. "Based On A True Story" is a series of six images that tell a mysterious tale involving a bed and a package. Cowin uses the technology to create striking gestures—the relationships of pitch blacks to light tones, the cinematic contrast between extreme close-up and long shot, a storyboard development of "scenes." "The manipulation is almost like darkroom manipulation," Cowin explains, "where you go in and lighten something up, bring something out. I didn't add or cut and paste anything....Sometimes when you're in the darkroom burning and dodging, it's difficult to get it perfect. But here, you can get it *perfect*....I work in a lot of different media: video installations and room-size photographic pieces. I like the way the object looks, from Nash. It's on this beautiful paper, and the way ink becomes part of the paper is beautiful. For me, it's more the object—where the technology's *under* the surface, not on top of it. To be able to get six images on one piece of paper, as we did in 'Based On A True Story,' is

really interesting. Jack Duganne and I played with the color of the print—'Based on a True Story' has a slight warm tone to it."

Olivia Parker has created a fascinating image in *Horseplay*: a smashed can patterned with an evanescent geometric design—like an architectural blueprint—and medieval-looking military figures on horses. In fact, the "architectural blueprint" comes from an Egyptian game board, to which Parker added dimension via the computer. The horsemen are taken from Parker's own photographs. Here, the artist actively engaged the computer qualities of Nash's equipment—the ability to shift digital information easily, creating combinations that would otherwise be impossible. Based in Massachusetts, Parker visited Nash and had what she calls a "tutorial" with Holbert. Since then, she's worked with Nash via disk and the U.S. mail. "The thing about working with a computer," Parker says, "is an image can evolve into something else in a way it can't in photography, and this fascinates me. Most of what I use is derived from my own photographs....*Horseplay* started with a four-by-five black-and-white negative of several figures—I wiped out all the figures but the one on the right. The people on horseback are from 35mm color slides I took. I use what they call the 'cloning tool' in Photoshop. It's almost as if you can paint one image into another, and you can vary the degree of transparency. It takes a long time. *Horseplay* took about sixteen hours of solid work, and the first time I did it, the computer ate it—there was a software glitch, which got fixed rapidly. As I was doing *Horseplay* again, I stored things along the way. And I think the second one is better....I've done a lot of thinking about what the computer is doing: I look at it as a tool to enable me to do things I could never do before."

One senses that the possibilities at Nash Editions are only beginning to be revealed, and, as with all beginnings, an innocence prevails. But a process has been established: a process that provides a new fine-print medium and expands the creative universe within which artists can explore. They have laid the groundwork for a new collaborative "studio," in which the centuries-old practice of fine printing adapts to the age of the computer.

Top: Nash Editions' Mac Holbert performs digital spotting in Photoshop; *above*: Holbert and Jack Duganne review fresh Iris prints on the drum. Photographs by Graham Nash.

Lynn Butler, *A Passage Through the Land of Sleepy Hollow,* 1986

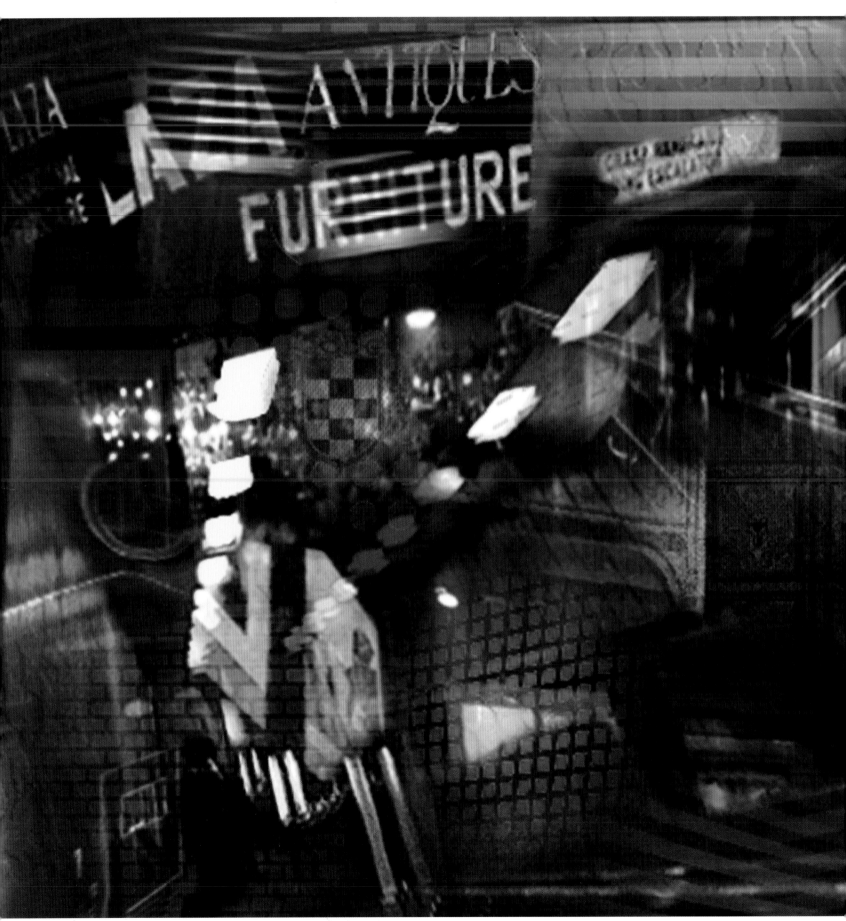

Annette Weintraub, *Escalation*, 1993

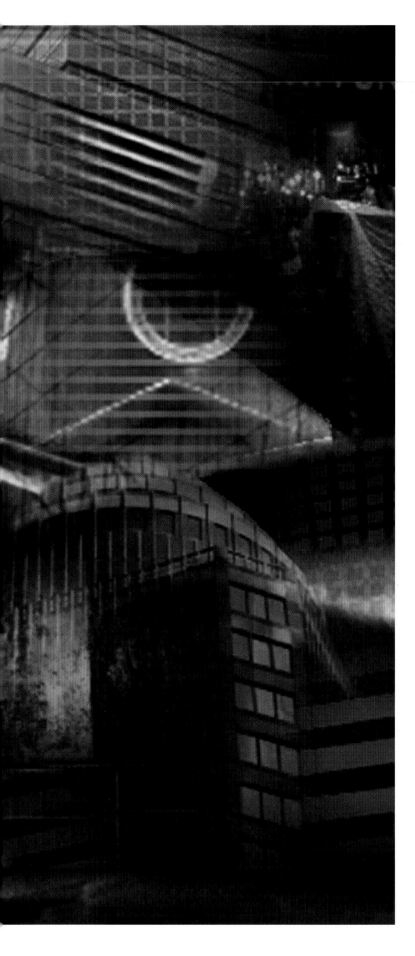

PHANTASM

DIGITAL IMAGING AND THE DEATH OF PHOTOGRAPHY

BY GEOFFREY BATCHEN

In 1839, faced with the invention of photography, Paul Delaroche is supposed to have declared, "From today, painting is dead!" A little over 150 years later everyone seems to be talking about the death of photography.[1] This outburst of morbidity appears to stem from two related anxieties. The first is an effect of the widespread introduction of computer-driven imaging processes that allow "fake" photographs to be passed off as real ones. The prospect is that, increasingly, viewers will discard their faith in the photograph's ability to deliver objective truth, and that the medium of photography will thereby lose its power as a privileged conveyor of information. Given the proliferation of digital images that look exactly like photographs, photography may even be robbed of its cultural identity as a distinctive medium. These possibilities are exacerbated by a second source of anxiety: the pervasive suspicion that we are entering a time when it is no longer possible to tell *any* instance of reality from its simulations. Sign and referent, nature and culture, human and machine; all these hitherto dependable entities appear to be collapsing in on one another to the point where they have become indivisible. Soon, it seems, the whole world will be turned into an undifferentiated "artificial nature." According to this scenario, the vexed question of distinguishing truth from falsehood will then become nothing more than a quaint anachronism—as will photography itself.

So photography is faced with two apparent crises, one technological (the introduction of computerized images) and one epistemological (having to do with broader changes in ethics, knowledge, and culture). Let's start with the first, the apparent displacement of photography by digital imaging. There is no doubt that computerized image-making processes are rapidly replacing or supplementing traditional still-camera images in many commercial situations, especially in advertising and photojournalism. Given the economies involved, it won't be long before almost all silver-based photographies are superseded by computer-driven processes. After all, whether by scanning in and manipulating bits of existing images in the form of data, or by manufacturing fictional representations onscreen (or both), computer operators can already produce printed images that are indistinguishable in look and quality from traditional photographs.

But what does this mean for the truth value of photography? Does it mean we will no longer believe in the truth of the photographic images we see in our newspapers or on our desks? The

47

problem with such a question is that traditional photographs—the ones our culture has always put so much trust in—have never been "true" in the first place. Photographers intervene in every photograph they make, whether by orchestrating or directly interfering in the scene being imaged; by selecting, cropping, excluding, and in other ways making pictorial choices as they take the photograph; by enhancing, suppressing, and cropping the finished print in the darkroom; and finally, by adding captions and other contextual elements to their image to anchor some potential meanings and discourage others. And we're not speaking here of just those notorious images where inconvenient figures have been erased from history—the production of any and every photograph involves some or all of these practices of manipulation. In short, the absence of truth is an inescapable fact of photographic life.

The thing about computers is that they let an operator do all these same things, but much more easily and in a less detectable way. The difference seems to be that, whereas photography claims a spurious objectivity, digital imaging remains an *overtly* fictional process. As a practice that is known to be nothing but fabrication, digitization abandons even the rhetoric of truth that has been such an important part of photography's cultural success. Ironically, given its association with new and intimidating technologies, digital imaging actually returns the production of photographic images to the whim of the creative human hand. This is perceived as a potential problem by those industries that rely on photography as a mechanical and hence nonsubjective purveyor of information. Anxious to show a concern for the integrity of their product, many newspapers are thinking of adding an *M* to the credit line accompanying any image that has been digitally manipulated. Of course, given that this credit line will not actually tell readers what has been suppressed or changed, it may simply cast doubt on the truth of every image that henceforth appears in the paper. But the dilemma is again rhetorical rather than ethical; newspapers have of course always manipulated their images in one way or another. The much-heralded advent of digital imaging simply means having to admit it to oneself and even, perhaps, to one's customers.

But at least photographs begin with an original negative and thus with an original model, a referent in the material world that at some time really did exist to imprint itself on a sheet of light-sensitive paper. Reality may have been manipulated or enhanced, but photography as a medium doesn't cast doubt on reality's actual existence. Indeed, quite the opposite. Photography's plausibility has always rested on the uniqueness of its indexical relation to the world it images, a relation that is regarded as fundamental to its operations as a system of representation. Even for cynical observers, a photograph of something has long been held as proof of its being, even if not of its truth. Computer visualization, on the other hand, allows photographic-style images to be made in which there is no direct referent in an outside world. Digital processes result in pure inventions that have no origin other than the computer program itself; they produce images that are no more than signs of signs. Thus, the reality the computer presents to us is

virtual rather than actual, a mere simulation of the reality guaranteed by the photograph.

This raises the question of whether photographs themselves have ever been anything other than simulations. If we look closely, for example, at photography's indexical relation to reality, the feature that supposedly distinguishes it from digital imaging, we find that this also involves no more than a "signing of signs."[2] In other words, photography turns out to be another digital process; it re-presents a reality that is itself already nothing but a play of representations. In any case, photographs are pictorial transformations of a three-dimensional world, pictures that depend for their legibility on a historically specific set of visual conventions. These conventions seem little different from those employed in most computer-generated imagery. The software packages that produce digital images depend on preexisting representational systems (electrical circuits, mathematical logic) and on familiar visual devices (perspective, photographic realism) to get their message across. In fact, at the moment, digital images remain dependent on photographic ways of seeing, not the other way around. And the computer itself continues to depend on the thinking and worldview of the humans who program, control, and direct it, just as photographs do. While the human survives, so will human values and human culture—no matter what image-making instrument that human chooses to employ.

This is where we run into the second of photography's sources of crisis. It should be clear to those familiar with the history of photography that a change in technology will not, in and of itself, cause the disappearance of the photograph and the culture it sustains. For a start, photography has never been any one technology; its nearly two centuries of development have been marked by numerous, competing instances of technological innovation and obsolesence, without any threat being posed to the survival of the medium itself. And even if we continue to identify photography with certain technologies, such as the camera, those technologies are themselves the embodiment of an idea, or at least of a persistent economy of desires and concepts. These include concepts of nature, knowledge, representation, time, space, observing subject, and observed object. Photography is the desire, whether conscious or not, to orchestrate a rather particular set of relationships between them.[3] While these concepts and desires endure, so will photography of one sort or another.

But are they indeed still with us? Technology alone won't determine photography's future, but new technologies, as manifestations of our culture's latest worldview, may at least give us some vital signs of its present state of health. Digitization, prosthetic and cosmetic surgery, genetic engineering, artificial intelligence, virtual reality—each of these expanding fields of activity calls into question the presumed separation of nature and culture, human and nonhuman, real and representation, truth and falsehood, on which

Opposite top: Deanne Sokolin, *Enrobed Head*, from the "Covering" series, 1993. *Bottom*: *Untitled*, from the "Covering" series, 1993.

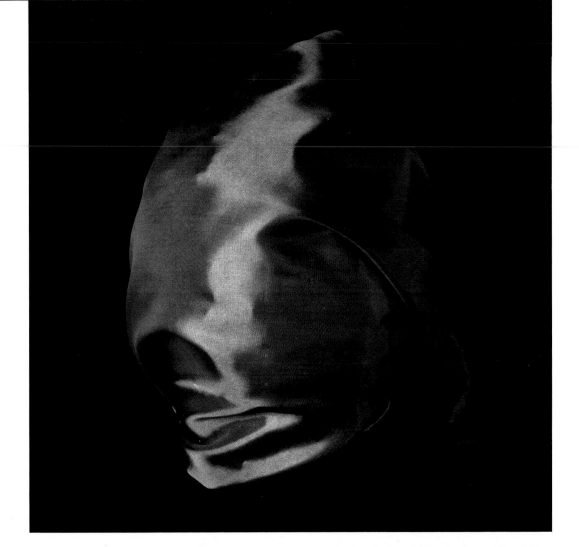

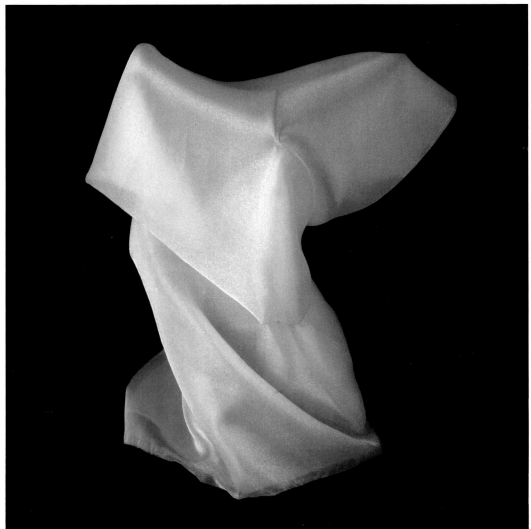

our photographic, so-called Cartesian epistemology has hitherto depended. Back in 1982, the film *Blade Runner* (a film all about the lived effects of the snapshot) looked into the near future and suggested we will all soon become replicants, manufactured by the social-medical-industrial culture of the early-twenty-first century as *more human than human*, as living simulations of what the human is imagined to be.

That century is almost upon us. And already there is no one reading this who is a "natural" being, whose flesh has not been nourished by genetically enhanced corn, milk, or beef, and whose body has not experienced some form of medical intervention,

MANUAL (Hill/Bloom), *Untitled*, from "Constructed Forest," 1993

from artificial teeth to preventive innoculations to corrective surgery. It is impossible to know where the human ends and interventions begin. Not that this is a new dilemma. Like any other technology, the body has always involved a process of continual metamorphosis. What is different today is the degree to which this fact is now a visible part of everyday life, a situation that insists on a radical questioning not only of the body, but also of the very nature of humanness itself. We have entered an age in which the human and all that appends to it can no longer remain a stable site of knowledge, precisely because the human cannot be clearly identified. And if "the human" is an unstable entity, can photography and photographic culture simply remain as before?

In recent years we have witnessed an increasing self-consciousnes regarding the identity of photography, a historical phenomenon that I have elsewhere called "post-photography."[4] A large number of artists, for example, now produce work that is photographic in character but nonphotographic in medium. In a return to the strategies of the Conceptual movement of the late sixties and early seventies, photographic imagery is made to reappear as solid transfigurations of glass, timber, plaster, wax, paint,

graphite, lead, paper, or vinyl. As if to mire forever the distinctions between taking and making, image and thing, we are presented with solid photo-objects that are designed to be seen, rather than seen *through*. In the process, the boundary between photography and other media—painting, sculpture, or performance—has been made increasingly porous, leaving the photographic residing everywhere but nowhere in particular. With post-photography, we are asked to enter an era after, even if not yet quite beyond photography. Like a ghost, this photographic apparition will continue to surprise us with its presence, long after its original manifestation is supposed to have departed from the scene.

This convoluted temporality points to the enigmatic quality of photography's death, or, more precisely, it forces us to question our present understanding of the very concepts of "life" and "death." Photography may indeed be on the verge of losing its privileged place within modern culture. This does not mean that photographic images will no longer be made, but it does signal the possibility of a dramatic transformation of their meaning and value, and therefore of the medium's ongoing significance. However, it should be clear that any such shift in significance will be an epistemological affair rather than a simple consequence of the advent of digital imaging. Photography will cease to be a dominant element of modern life only when the desire to photograph (and the peculiar arrangement of concepts which that desire represents) is refigured as another social and cultural formation. So the end of photography cannot leave the equivalent of a clean slate. Indeed, photography's passing must necessarily entail the inscription of another way of seeing—and of being. Photography has been haunted by the spectre of such a death throughout its long life, just as it has always been inhabited by the very thing, digitization, which is supposed to be about to deal its fatal blow. In other words, what is at stake in the current debate is not only photography's possible future, but also the nature of its past and present.

1. See, for example, Timothy Druckrey, "L'Amour Faux," *Digital Photography: Captured Images, Volatile Memory, New Montage* (exhibition catalog, San Francisco Camerawork, 1988), pp. 4–9; Fred Ritchin, "Photojournalism in the Age of Computers" in Carol Squiers ed., *The Critical Image: Essays on Contemporary Photography* (San Francisco: Bay Press, 1990), pp. 28–37; Anne-Marie Willis, "Digitisation and the Living Death of Photography," in Philip Hayward ed., *Culture, Technology & Creativity in the Late Twentieth Century* (London: John Libbey, 1990), pp. 197–208; Martha Rosler, "Image Simulations, Computer Manipulations: Some Considerations," *Ten.8*, "Digital Dialogues," 2:2 (1991), pp. 52–63; and William J. Mitchell, *The Reconfigured Eye: Visual Truth in the Post-Photographic Era* (Cambridge, Mass.: MIT Press, 1992), particularly p. 20.
2. See Jacques Derrida, *Of Grammatology* (Baltimore and London: The Johns Hopkins University Press, 1976), pp. 48–50.
3. See my "Burning with Desire: The Birth and Death of Photography," *Afterimage*, 17:6 (January 1990), pp. 8–11.
4. See my "On Post-Photography," *Afterimage*, 20:3 (October 1992), p. 17.

Opposite: Diane Fenster, *Night Six*, 1992

PORTFOLIOS II

THE VIRTUAL LANDSCAPE

KATHLEEN RUIZ IT IS THE UNSEEN, INTERIOR STRUCTURES OF NATURE AND THOUGHT THAT INTEREST ME: THE BORDER BETWEEN PHYSICAL, OBJECTIVE SPACE AND INCORPOREAL, SUBJECTIVE SPACE. My work is concerned with issues of restructured reality as evidenced in encrypted messages of presence, absence, and transformation.

Sometimes I work from pictures that I take with a 35mm camera and from photomicrographs. For other work, I create photographs of thoughts—"virtual" objects that I create within the computer. Since these depict objects that do not exist in the physical world, they are essentially photographs from my mind.

Opposite:
Kathleen H. Ruiz,
*Enumerated
Repository:
Random
Mummy*, 1991
Left:
Kathleen H. Ruiz,
Shell construct A,
1991

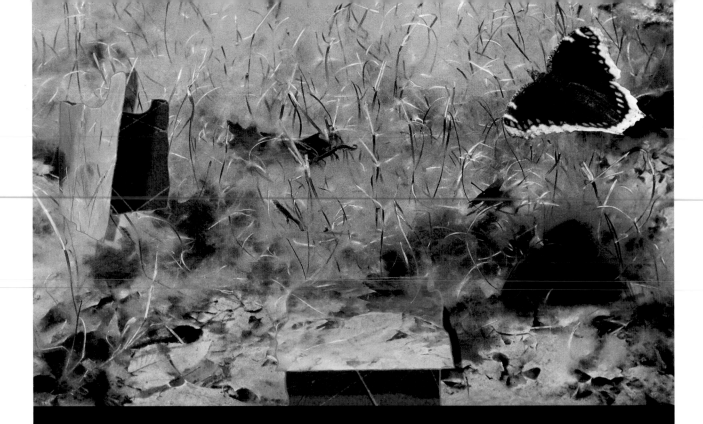

PETER CAMPUS I BEGAN WORKING WITH THE COMPUTER ABOUT FIVE YEARS AGO, AND SOON FOUND THAT IT ALLOWED ME TO BRING OUT THE QUALITIES OF MY PICTURES THAT I CONSIDERED IMPORTANT. I could change color and texture, eliminate some parts and exaggerate others, distort, alter, or invert tonalities, merge images, and fabricate backgrounds. In this way I could make the contents of my pictures more apparent. I like to take objects (my subjects) out of context to reveal something about them, to make a larger point, or a more personal point. Lately, I've wanted to show how we sentimentalize nature and, in so doing, erode it.

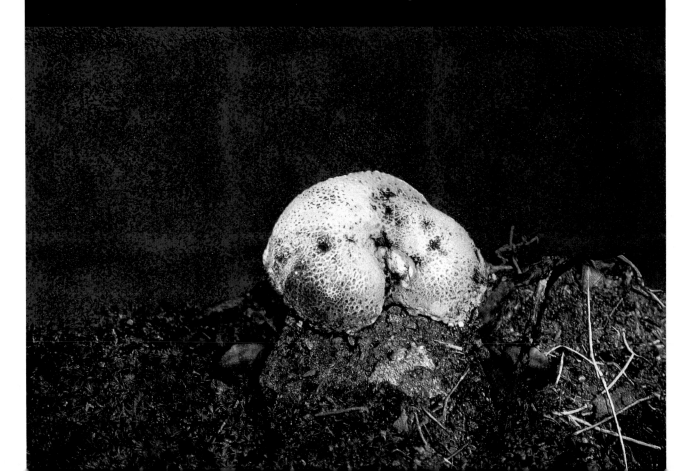

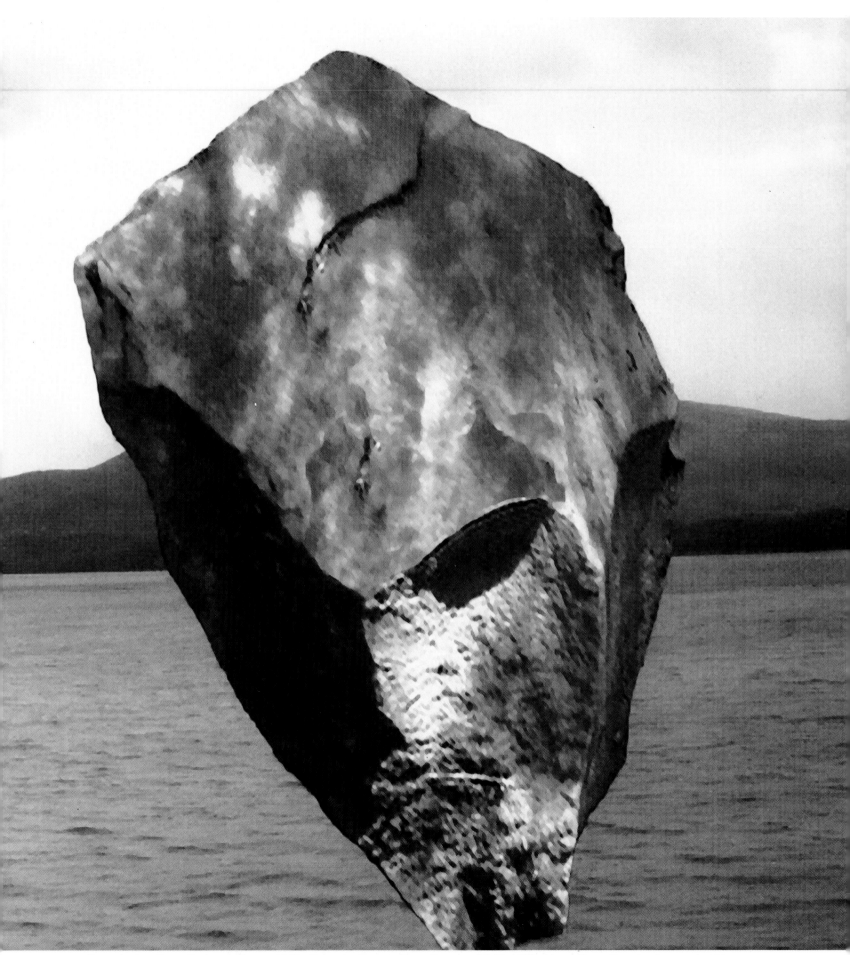

Opposite top: Peter Campus, *Flutter*, 1993. *Opposite bottom*: Peter Campus, *Mold*, 1993. *Above*: Peter Campus, *Journey*, 1992

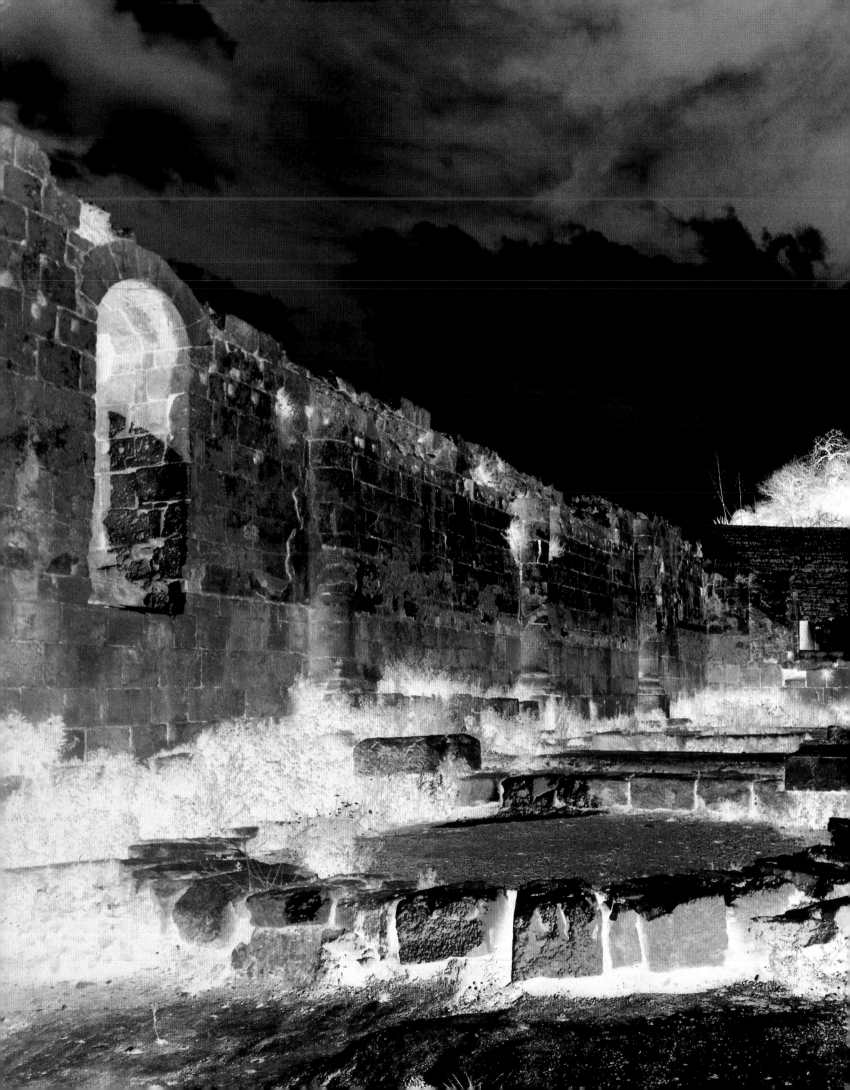

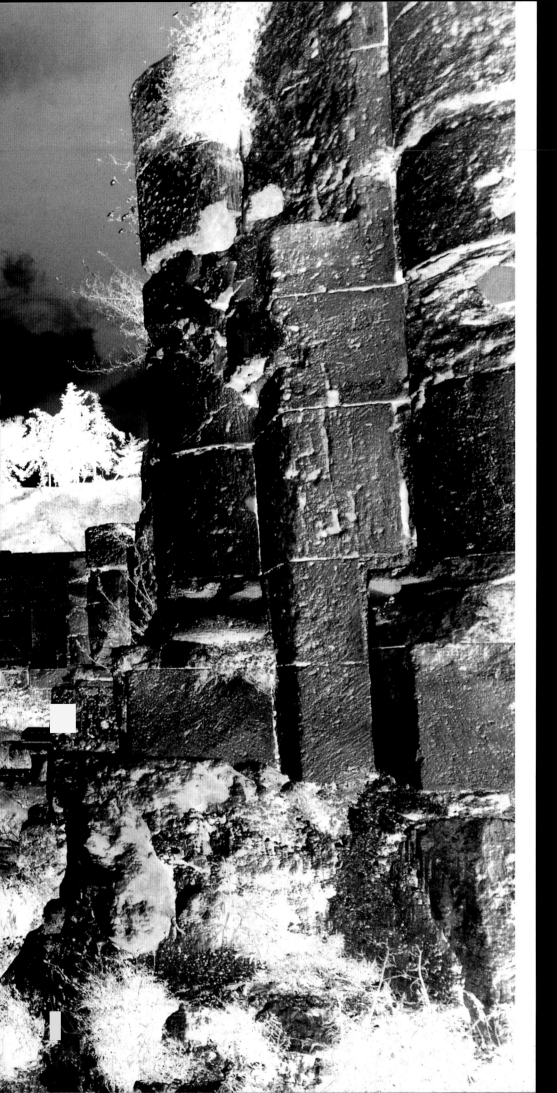

BARBARA KASTEN

THE ROMAN QUARRY OF EL MÈDOL WAS ONCE A WORKING, INDUSTRIAL MINE, BUT NOW IT HAS BECOME A ROMANTIC SETTING WITH THE AURA OF A CATHEDRAL. Eras, layered one upon another, echo among the stones of Tarragona and resonate from the beautiful void of the quarry itself. A negative cavity in the landscape remains with only a needlelike marker to gauge the missing density that once filled it.

Using light and montage, camera and computer to deconstruct and distort the reality of the site, I have made an image of El Mèdol as it does not exist. The color of gold was used to symbolize magnificence, sacredness, and preciousness; red represents the intensity of the human endeavor to hollow out the void; purple and blue represent the past and the royalty that benefited from the toll of the workman. The panoramic mural monumentalizes the historical function of stone and simultaneously underscores the absence of function that has now become the identity of El Mèdol.

Roman Amphitheater, Medieval Church, Tarragona, Spain, 1992

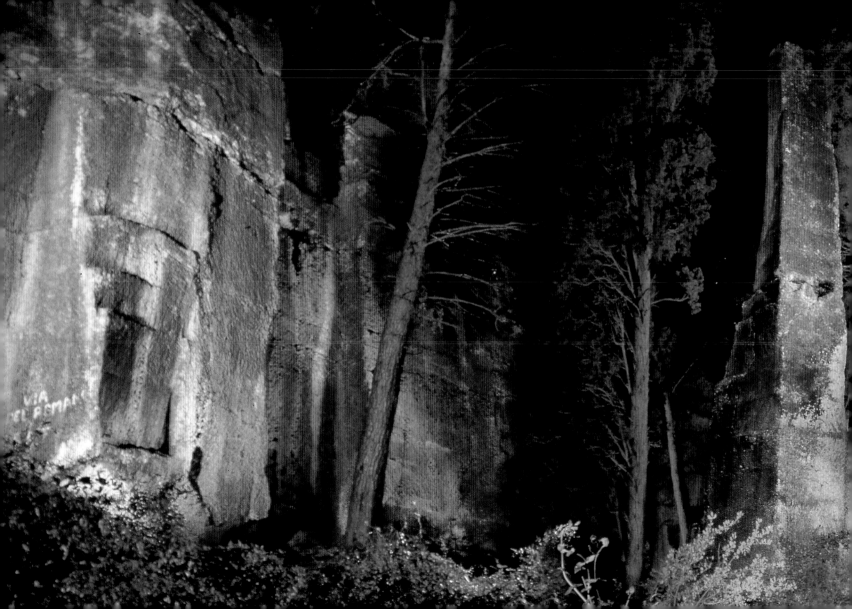

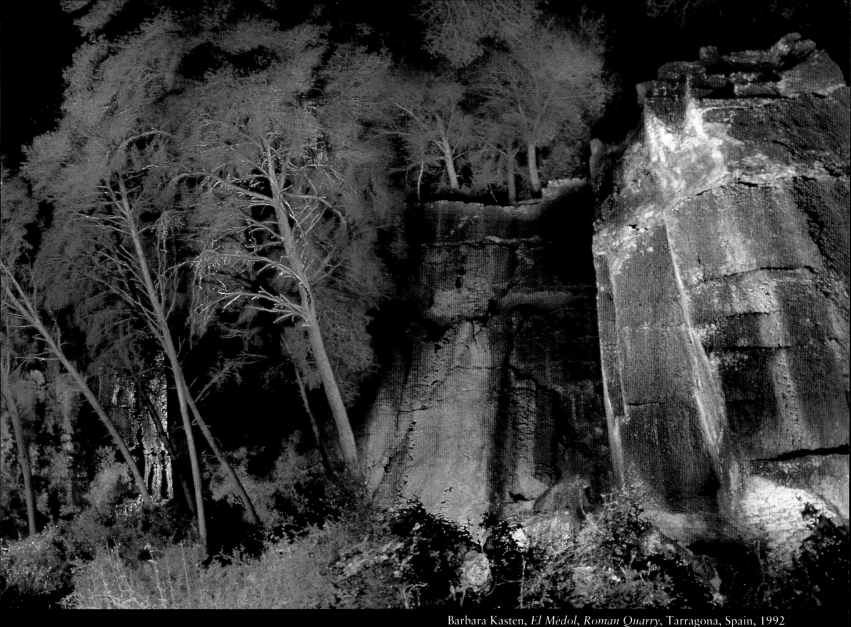

Barbara Kasten, *El Mèdol, Roman Quarry*, Tarragona, Spain, 1992

Barbara Kasten, *Gold Creature*, Tarragona, Spain, 1992

Barbara Kasten, *Blue Creature*, Tarragona, Spain, 1992

PAUL THOREL

WHEN MAKING A
PORTRAIT, I START BY
PHOTOGRAPHING A
PERSON IN DIRECT
LIGHT AND THEN
BEGIN THE PROCESS
OF ELABORATION
WITH THE COMPUTER.
Every effect of form and
light that surrounds my
portraits is caused by the
insertion of an image or
detail into the original
portrait. The computer
allows me to store differ-
ent images in the same
plane and frame. Every
stage in the development
of a portrait is subject
to random influences;
the aesthetic result of
the encounter between
images is only predictable
in the imagination. My
current work addresses
the concept of *recogniz-
ability*. It consists of faces
in transformation, at the
moment before an
expression fades.

Biagio C., 1993

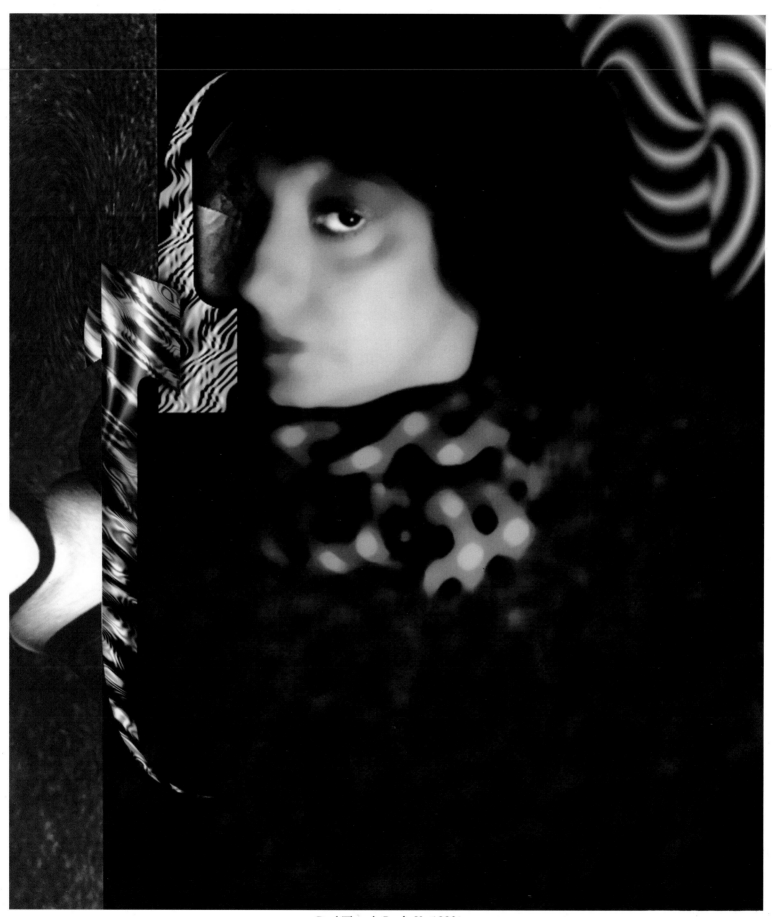

Paul Thorel, *Paola V.*, 1993

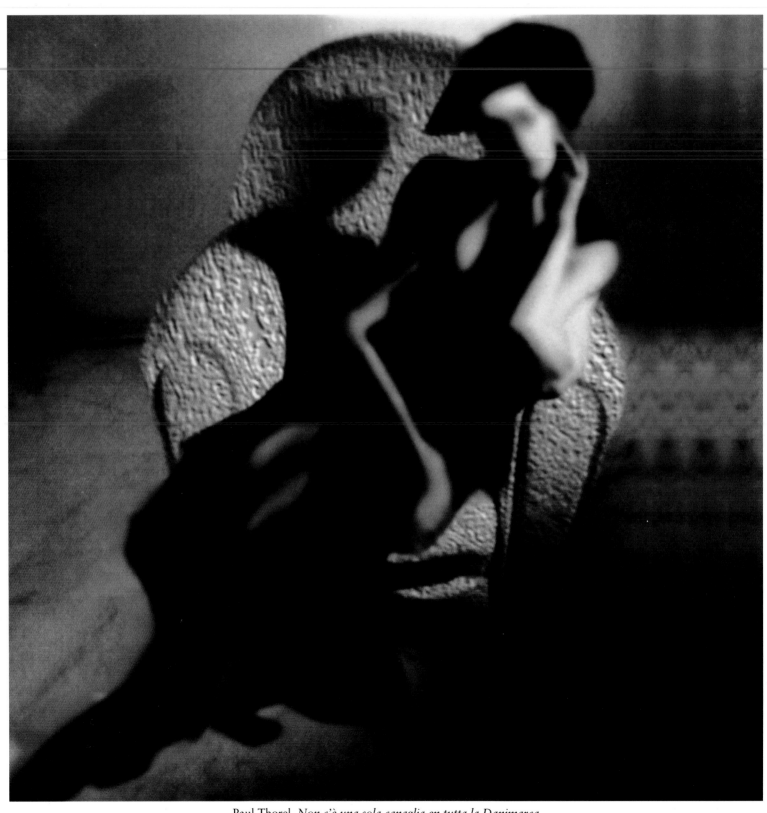

Paul Thorel, *Non c'è una sola canaglia en tutta la Danimarca*
(There is not a single rascal in all of Denmark), 1988

Paul Thorel, *Elle avait hâte de se lever pour secouer cette meute imaginaire*
(She couldn't wait to wake up and shake off this imaginary pack [of wolves]), 1992

Paul Thorel,
*Trois fillettes s'en
vont en guerre*
(Three little girls
go to war), 1992

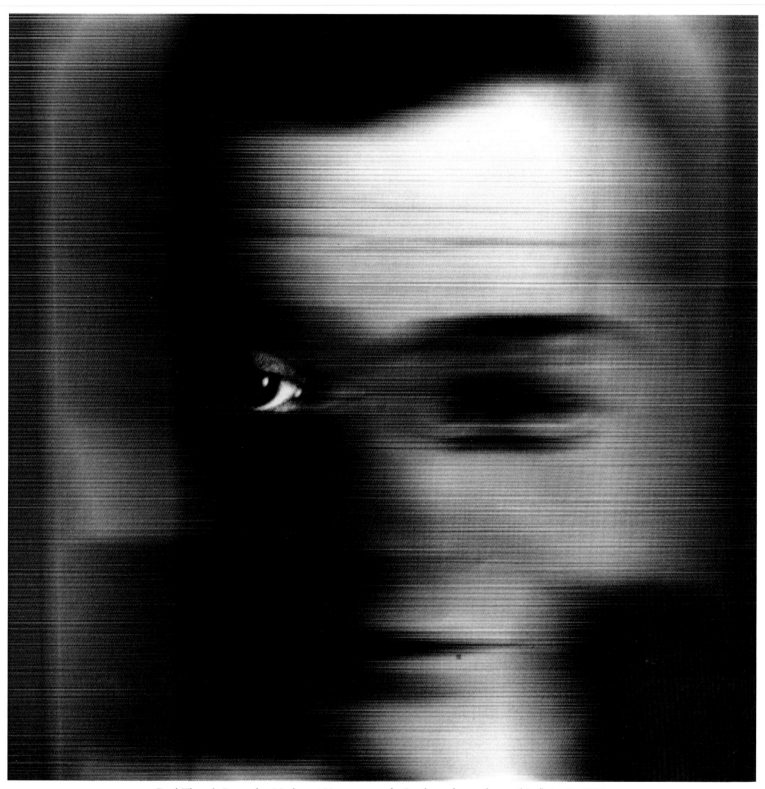

Paul Thorel, *Regardez Madame! L'escargot vole* (Look madame, the snail is flying!), 1988

PEOPLE AND IDEAS

THE DIGITAL MUSEUM

By Ben Davis

Museums are repositories for evidence: evidence that events have occurred, phenomena have been noted, human expression persists. Museums remind us that we are not and have not been alone. But many cultures exist without museums. In cultures such as the Balinese, evidence is stored in the collective memory and preserved by being spoken. Memory, then, is the repository for this kind of culture. The more a memory is invoked and disseminated, the more important that piece of information becomes to giving the culture a survival code. In Western culture, museums serve both as our memory and to give value to evidence. Something in a museum is worth more, perhaps, because it is provided with constant care, and as it is researched and written about, it accumulates value. An object without an anecdote is impoverished. Circulating images of such objects is a critical acknowledgment that those objects have significance.

Museums are starting to use digital-imaging technology in a variety of ways, from archiving their collections to educating and communicating with the public. For a museum, digital record-keeping is efficient, but digital communication is problematic. For the computer, the two functions are integrated. Depending on how museum digital information is modeled, digital evidence can flow out of the museum record-keeping system into the educational system, the entertainment system, or the economic system, resulting in a multitiered digital museum.

Objects within Objects

The three main concerns for digital museums are storage, retrieval, and interaction. *Storage* involves methods of recording images and data, file formats, compression ratios, and annotation fields. What level of detail is held in the fields of information about an object? In addition to identifying a work and its maker, a digital file might tell you where an image has been reproduced and for what purpose. You could find out what condition an object is currently in, how many other objects like it exist or have existed, what the object is currently worth, and to what uses it may be put. If a digital image of the object is included, a host of other questions arise: How much resolution and color is required to represent the artwork faithfully? How many bits of information in this image are public property? How much of it is private?

Digital archivists must also determine what parameters to place on the *retrieval* of this kind of information. Who can get at information about artworks, for instance, that provide reference for the art market? How is software constructed to allow access to certain information and restrict access that might endanger the security of the work?

And finally, how is *interaction* with the information performed? Can the data and digital image be removed from the collection for any purpose? Can enough bits be accessible for reproduction? The issues of storage, retrieval, and interaction will determine the future of digital museums, which could evolve as electronic studios, allowing museum data and imagery to become a resource for the creation of new art and critical thinking, or as large-scale image banks and publishing resources.

Our relationship to original works of art may also change in the process, along with our ideas of connoisseurship. Theoretically, by offering the general public greater opportunities to interact with and learn about works of art, the digital museum could make for a pro-active audience—one that is creative rather than passive. On the other hand, digital archiving could make the original work of art more precious.

Another possibility is that art may come to be seen as the transparent commodity that it is. As in the stock market, the general availability of art data over networks could make the buying and selling of cultural artifacts a public rather than a private transaction. Legally or illegally exchanging access to databases could create an open art market, or could lead to security systems as dense as those of world banks. To build digital museums is to reveal the essential nature of conventional museums. Dematerializing objects and creating virtual buildings that anyone with a computer and a modem can visit makes a transactional space of the conventional museum. At the same time, the digital file is the link to the valued object.

Digital museums are project driven. Each time an art collection is the subject of a digital-imaging project, museums move closer to having an electronic system for cataloging, exhibitions, and product development. Choosing collections for these kinds of initiatives means creating a digital museum inside the physical museum, as well as "substituting" a digital object for the real object.

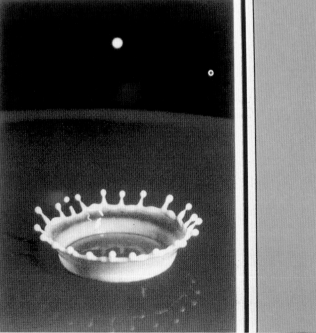

The digital Edgerton museum

Seeing the Unforeseen

The MIT Museum at the Massachusetts Institute of Technology is initiating the digital process with the photographic work of Harold "Doc" Edgerton, the inventor of the electronic strobe. The Edgerton Foundation, the MIT Edgerton Center, the George Eastman House, the MIT Center for Educational Computing Initiatives, the MIT Archives, and the MIT Museum are all sharing responsibilities in this endeavor. This is a hyperorganization to create a hypermuseum.

The project had an uncanny beginning. On January 4, 1990, I was having lunch in the MIT Faculty Club with Kenneth Goldman, an officer of the MIT Industrial Liaison Program. Goldman noticed Harold Edgerton nearby. I told him that I had always thought Edgerton's work would be a perfect subject for interactive multimedia, and wondered aloud whether I should mention this to Edgerton while he was having lunch. Goldman thought it might be prudent to wait until after he had eaten. I deferred to his judgment. Edgerton got up and went to pay his bill at the cashier, had a massive heart attack, and died.

Needless to say, the event was disturbing. Somehow it made Edgerton's images seem all the more moving, as testaments to the arresting of time. The objects to be archived—the Edgerton photographs and films—are essentially evidence that a phenomenon was recorded accurately. The more accurate the rendering of the phenomenon, the "better" the photograph, the closer to art the rendering becomes. The beauty of the Edgerton images is that they are precise abstractions of reality. They show that science and art are separated by a very thin filter of time and intention. Artistically, Edgerton's photographs are like simulacra that involve viewers in the extraordinary and magical act of conjuring within the ordinary world. As a product of science, these pictures have another value: they act as a reward for synchronizing technology and events into moments of vision—a reward for learning something.

Today, this kind of conjuring is carried on at MIT by Charles Miller, who experiments with strobe and multiflash at the Edgerton Center, with students of all ages. The students themselves produce Polaroid images of the phenomena. They usually get the picture wrong at first, fail to synchronize the event, the light, and the camera. Successive tries finally produce a rewarding result—an image that captures the spirit as well as the data.

A digital image of an Edgerton picture could be said to be a clone of an experience. The original Edgerton was a record of the magic reality *behind* human vision. The digital reproduction of it makes a temporal object of the image that preserves the original by being infinitely reproducible without loss of detail. (Edgerton, of course, would probably have wanted a digital camera capable of making the recording firsthand.)

The Edgerton project has many facets. Funded by the Edgerton Foundation, the work consists of cataloging the vast number of Edgerton-related materials in a digital database at the MIT Museum, creating an interactive multimedia exhibition on the life and work of Edgerton for the George Eastman House exhibition opening in November 1994, and setting up an interactive multimedia program for fifth through eighth graders on Edgerton as a scientist, inventor, artist, and teacher. The digital Edgerton museum will be network accessible as a resource for creative thought and productivity at MIT as well as at other museums and institutions.

Basically, this project is an "extended biography"—the life of a single individual used as an example and a stimulus for interactive experience. In the case of Doc Edgerton, his life's work was the creation and demonstration of technologies that allowed ordinary events to be viewed and examined in extraordinary ways. This work is especially relevant for young students as they search for meaning in educational experience and begin to discover what their own life's work might be. The study of science and engineering is especially pertinent to this context, as it provides a window into the examination of everyday experience by using technology, mathematics, and theory as tools of exploration. The products of Edgerton's inquiries also happen to be aesthetically rewarding, providing an even richer set of experiences.

The Digital Object

At the other end of this process is the digital object. The digital object is a mass of linkages and (to use a collage of Marcel Duchamp's phrases) an "infrathin of standard stoppages." Whose object is the digital object? How does it function as an artifact? Can you make something new out of it? How do you catalog art made of digital objects? What is it worth?

In 1986 the Musée d'Orsay opened in Paris. It was the first museum to open with the intention of having a digital collection available for public browsing. About seven hundred images of artworks, dating from 1848 to 1914, were digitized and put into files that are served to a dozen workstations. Museum visitors can look up artists' names and titles of works and then access a single image displayed on a large screen. There is no network access to the images outside the museum. In an effort to make a visual browsing interface,

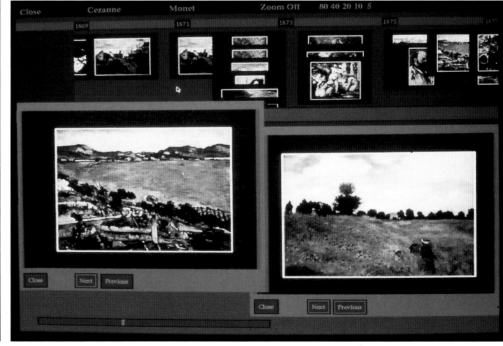

On-line catalog at the Musée d'Orsay, Paris

the MIT Center for Educational Computing Initiatives built a time line, the Chronograph, that would display images strung along changeable sets of dates. This makes it possible to compare different artists' works visually, and then to access text information. It reverses the traditional catalog structure, in which text is the primary identifier. The focus is on what users of museum information need, rather than what they are usually taught they need. The digital museum can be visitor-centered rather than curator-centered.

Ironically, however, the Musée d'Orsay does not encourage the "touch-screen" as an interface. The fear is that less sophisticated visitors might be encouraged to handle originals once they leave the digital museum and enter the actual museum. After all, valuable works of art hang on the walls without any physical protection other than the electric eye that beeps when you get too close. If the digital museum is a convincing enough environment, the boundaries between the original and its computer simulation could blur.

There are more than five thousand museums in the United States. What if all their digital collections were accessible via network? What kind of a museum would that constitute? What about worldwide access? What kind of computer fraud could we imagine? What kind of licensing structures? What about private collections? Dealer databases?

Perhaps there will be free admission on Thursday evenings to the digital-museum network. What about a multicultural distribution specialist, who puts a "voice" on collections for orientation? The public may come to expect more and more technology and digital services. Blockbuster exhibits may have to provide virtual reality that can be accessed from home. The orchestration of the facsimile and the original to heighten the importance of the original may become a major preoccupation of art dealers and collectors—how to distribute the digital simulation as a kind of advertisement for the real thing. If the digital museum object is active on the system, it is "on display" constantly.

The digital museum really asks, "Why do you want to know about art?" What is the real value of this phenomenon? In the end, if it is developed with educational as well as commercial imperatives in mind, the digital museum will allow us to appreciate the analog—the handmade object—and all that it represents.

VIRTUAL REALITY CHECK:
AN E-MAIL INTERVIEW WITH BRENDA LAUREL

By Michael Sand

The following interview with Brenda Laurel took place via electronic mail over the course of four weeks at the beginning of 1994. The coding before the first question and response is standard transmittal information for messages sent over the Internet, the world's largest information network. For the sake of clarity in print, coding has been omitted for subsequent messages.

```
From:    IN%"MISAND@delphi.com"
To:      IN%"brenda@vr.com"
Subj:    RE: aperture to laurel
MIME-version: 1.0
Content-type: text/plain;
         charset="us-ascii'
Content-transfer-encoding: 7BIT
```

You went from a background in theater to developing video games at Atari in the early eighties. Was that a difficult transition for you? And for Atari?

```
From:    IN%"brenda@vr.com"
To:      IN%"MISAND@delphi.com"
Subj:    RE: aperture to laurel
Message-id: <6940012236.AA23777
         @virtual.reality.com>
MIME-version: 1.0
Content-type: text/plain;
         charset="us-ascii"
Content-transfer-encoding: 7BIT
```

Actually I started working on video games as a sideline (a way to stay alive) while I was still in graduate school studying acting. It seemed quite natural. It was not hard. Atari was amusing, lots of boys, mostly stoned.

>MS: I once heard you describe virtual reality as "the oxymoron of the century." What did you mean by that?

>BL: Well, if it's reality it's not virtual, or if reality is virtual, then it's not singular. Maybe "virtual realities" would have been a better name.

>MS: Is the "virtual" anything more than a glorified version of the "imaginary"?

>BL: Not EVEN glorified…. The intent of calling something "virtual" in the context of VR (virtual environment, virtual body, etc.) is to say that it is a multisensory representation of some imaginary object, or of a real object in an imaginary context. It's the sensory representation part that's important.

>MS: What senses other than sight can experience virtual reality with current technology?

>BL: "Placeholder," the project we did at Banff, pushed 3D audio farther than any other VR project I know of. Audio was by far the strongest component of the piece. Each participant could hear eight independent spatialized sound sources (including the voice of the other participant, coming from the "right" place) that could be dynamically reallocated, which enhanced the apparent richness and complexity of the auditory environment.

We also tried to optimize kinesthesia in several ways—to give people more of the

The designers experiencing the world as critters. The design of the physical installation is part of people's experience of the place.

Graphic design of the map of the world, shown to visitors as part of their orientation

 The graphic elements in Placeholder were adapted from iconography that has been inscribed upon the landscape since Paleolithic times. Narrative motifs that lend expression to archetypal animals and landscape features were selected from aboriginal tales. Four animated spirit critters—Spider, Snake, Fish, and Crow—inhabited this virtual world. A person visiting the world could assume the character of one of these spirit animals and thereby experience aspects of its unique visual perception, its way of moving about, and its voice. Thus the critters functioned as "smart costumes" that altered more than the appearance of the person within.

Using three-dimensional videographic scene elements, spatialized sounds and voices, and simple character animation, we constructed a composite landscape that could be visited concurrently by two physically remote participants using head-mounted displays. Features and objects found in the actual places were reassembled here to serve as vehicles for exploration and play. People could walk about, speak, and use both hands to touch and move virtual objects.

(Text and images from Placeholder, a virtual-reality project developed and produced by Brenda Laurel and Rachel Strickland while in residence at the Banff Center for the Arts, in Alberta, Canada.)

pleasure of movement. Most VR systems infer intended direction of motion from a tracker on the head. We put a tracker on the pelvis as well so that direction of gaze and intended direction of motion were differentiated. This gave people much more flexibility with their backs and necks. Also, most VR systems only work with a single Dataglove, worn on the right (or "dominant") hand. Now, if you believe in cerebral dominance, you might think that having only your right hand in the world would impair not only what you could do, but what you might think of doing! So we developed a two-handed system, using very simple devices called "Grippees," which did not track minute finger motions (since we didn't need that information), but told the system where the hands were in space, and whether a person was touching or grasping some virtual object. Tracking these hand sensors also made it possible to let people fly by flapping their arms when they were embodied as the character Crow. Finally, we avoided the "gestural language" that has become standard in VR through military and NASA applications (e.g., pointing to fly)—nobody had to learn anything special; you just did stuff by doing it, which also increased the sense that you could move freely and that your whole body was an interface.

We gave a lot of thought to simulating wind with a fan in the studio, but we didn't get around to it. Our audio engineer, Rob Tow, did an amazing job of designing wind,

with wandering sound sources that made it sound like ambient noise rather than point-source sound. Really cool.

>MS: Placeholder requires the use of a helmet and cables. How comfortable an interface is this?

>BL: Well, it is a major pain in the neck to wear a head-mounted display (HMD). Wirelessness is possible but not practical—yet. There are other alternatives, like 3D surround projection, that don't require you to wear special equipment, but there are severe limitations on the shapes and sizes of virtual spaces that one can experience through projection. I don't think you can do immersive VR well without some kind of HMD. The paraphernalia will become less cumbersome—probably very lightweight and slick—well before the turn of the century.

>MS: Where can people try Placeholder?

>BL: People probably won't be able to try it. The installation involved five people and eleven computers and a good bit of duct tape, spit, and baling wire just to run it. Some of the hardware belongs to Banff, some belongs to Interval Research, and some was returned to the various places it was borrowed from. The code was fragile at best and would have to be reconstructed very carefully. The audio engineering wizard who designed and ran the 3D sound,

In order to emphasize visual flowfield, full-motion video is projected onto an anamorphic "screen."

Detail of the hoodoos, as seen from inside the model in VR. Crow and fish can be seen.

 Placeholder explored a new paradigm for narrative action in virtual environments. The geography of Placeholder took its inspiration from three actual locations in the Banff National Park: the Middle Spring (a sulfur hot spring in a natural cove), a waterfall in Johnston Canyon, and a formation of hoodoos—natural columns of rock that assume fantastical forms—overlooking the Bow River.

The people who visited Placeholder changed it, much as travelers often leave marks in natural places—pictograms, petroglyphs, graffiti, or trail signs, for example. In Placeholder, people could ceate "voicemarks"—bits of spoken narrative—that could be listened to and rearranged by subsequent visitors. The virtual landscape accumulated definition through messages and storylines that participants left along the way.

Dorota Blaszlek, has returned to Poland. There is not much chance of the piece being reassembled. It was like live theater in the sense that it was quite ephemeral.

The main point in doing a piece like this is to see what can happen when you push on certain edges. I think we did that in several ways, and we learned a lot from it. Now we are able to tell a story about what happened that we hope will encourage people to understand VR a little differently—to have new ideas about what the medium can do and how it can mean, if you know what I mean.

>MS: Let's turn from virtual space to cyberspace for a moment…. What do you think of the idea of the Internet as a democratic realm, where more people have access to more information, and where people feel freer to express themselves?

>BL: This is a very complex issue! A lot depends on how access and content are sorted out. Right now the design of interfaces and the cost of hardware and line time are real barriers for non-dweeb, non-middle-class people. I expect that this situation will change radically as more and more commercial opportunities begin to be exploited. A related problem is that the "information superhighway," while it may increase access and improve the interface to certain kinds of content, may effectively strangle all the incredibly rich back roads (so long, Route 66). While I don't in fact think this will be a permanent state of affairs, we will probably have to go underground (as usual) until the commercial "content providers" and their buddies in infrastructure land stake out their claims and shove more of their worldview down our collective throats… [sounds of strangulation…].

>MS: I've heard stories of men joining conference groups or on-line discussions as though they were women, and vice versa.

Are there potential dangers to this kind of interaction? Is this safe sex?

>BL: Well, the dangers aren't much worse for adults than getting gender signals wrong on the street (or in a bar), I don't think, and I believe that it's generally good for people to have to *construct* a gender identity as a volitional act—at least it brings the constructed nature of gender back into our consciousness. For kids I think that this positive effect is even more pronounced. Teens are stuck with a meager palette for self-representation (including gender) in "real life." And distorted ideas about "gender appropriateness" can lead to low self-esteem—for both boys and girls. So hey kids, take back your gender ID!

>MS: Where is cyberspace?

>BL: Where you go when you're on the phone. Where your body goes when you are at the movies (unless you spill a Coke on your lap).

[Grateful Dead lyricist John Perry] Barlow says that cyberspace is where your money is.

Depends on what's going on. Between your ears when you're having a heavy discussion. Between your legs when you get hot e-mail.

On your skin, retinas, eardrums. Body and brain all hooked up, when it's working.

Press RETURN for more….

A DEFINING REALITY: THE PHOTOGRAPHS OF NANCY BURSON

By Rebecca Busselle

Humans alone are adaptable, while machines are doomed to obsolescence. —DANA FRIIS HANSEN

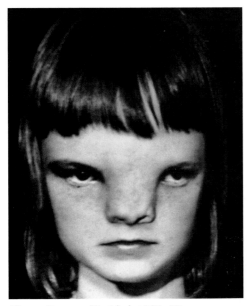

Nancy Burson, *Untitled*, 1988–89

Elevator doors part onto main exhibition space of the Jayne H. Baum gallery. The scene resembles a children's birthday party more than a sedate SoHo opening, despite a sizable representation of black-clad adults. Kids tear around trailing silver balloons on strings. In an adjoining room, a crowd of people await their turn at an interactive computer station—a high-tech, black plastic cubicle with a video screen and a built-in seat. The gallery noise level is high and punch has been spilled on the floor. Serene in the middle of this, Nancy Burson talks to visitors. Her husband and collaborator, David Kramlich, comforts a weeping five-year-old who points to a balloon on the ceiling. On the walls, in wide brushed aluminum frames, hang the diffuse, dreamlike images of children who have been Burson's subjects for over three years. And some of those she photographed—her honored guests—mingle in the gallery today.

Best known for digitized composite portraits, many with a political or cultural message, Nancy Burson also holds a patent on a computer system that simulates aging in adults and children. An eleven-page resume, including over a dozen national television appearances, certifies her preeminence in this technological field. Yet for the past several years she has used a simple, plastic Diana camera to photograph children born with craniofacial conditions or progeria, children considered difficult to look at, although Burson describes them as having "unusual, very special faces."

No longer content with conceptual work, Burson has chosen to make unaltered photographs of highly challenging subjects, those whom our eyes avoid, or those at whom we stare. In a world of increasing virtual reality, she returns to a defining reality, one that sheds the superfluous. Children with the rare condition progeria will age a lifetime during a few years and die before adulthood. Children with craniofacial disorders may have dozens of surgeries before they feel confident in public. How did an artist who spent two decades working with pixels and grids—and earned a formidable reputation doing it—arrive in this world of painful, yet soft, ethereal images? And how did the process of working with computers—machines, after all—redefine her, bring her closer to essential human problems?

A painter who grew up in St. Louis, Burson arrived in New York in 1968. Shortly after moving to the city, she became excited by the Museum of Modern Art's exhibition, "The Machine as Seen at the End of the Mechanical Age," in which visitors became more than viewers by interacting with the art. For Burson, it brought back the childhood thrill of carnival games, and the pleasure she felt when a photo booth spit out a strip of self-portraits. Twenty years old herself, she happened on magazine illustrations projecting the Beatles as they aged. Burson began to imagine sitting before a video screen and with the aid of dials or buttons, watching herself grow old.

She approached Experiments in Art and Technology (EAT) to help her develop an aging machine. Although her mother was a lab technician, Burson had little scientific background, and remembers upsetting her biology teacher by shading her biology drawings, thereby prophesying her synthesis of art and science to come. Paired with an EAT computer-graphics expert, she learned that her vision was ahead of the available technology. She would have to wait. She returned to conceptual painting, which both intrigued and bored her, but the vision of her aging machine was never far from her mind.

Burson stayed abreast of the technology, and almost a decade later MIT accepted her proposal "to simulate the aging process." In this early stage of digitization, more than sixty seconds were required to scan a face,

Nancy Burson, *Baby Elvis*, 1988

Nancy Burson, *Untitled*, 1991

choices become automatic; earlier it would take "nights and nights of processing." As Burson describes it, "The whole thing was slow and it wasn't very good." Once again, the technology lagged behind the idea. The aging machine became a media event before it was perfected, which Burson found awkward, since "people wanted to use it and it didn't really exist." In 1982 she began work with Richard Carling and David Kramlich to develop software that met the standards of her vision and increased processing speed. She credits the success of her projects to this ongoing collaboration.

In 1983 Burson exhibited her portraits of the British royal family in the year 2010, which included a composite of baby William. Through a liaison working with missing children, a Florida family asked her to update their daughter, who had disappeared seven years before. Burson declined at first. "We'd never done anything like that, and then I began to think about it. Maybe it would be possible if we used the composite process, taking a percentage of features from an older family member and adding that to the last known picture of the child. Maybe it would automatically update the facial structure. And that's pretty much what we did." She and Kramlich participated in a number of missing children cases, and then they were called in to help the FBI find Etan Patz. The six-year-old New York boy, who disappeared in 1979, has never been found. But within the first year of using the updating process, several children were located. Burson realized that a very human use had come from the technology, one she had not expected. "I was never sure that it would work," she says, "and when it did work and kids were found, I was surprised. But on another level I wasn't surprised at all. It was like MIT—blind faith." What had begun as conceptual computer art took her into the anguish of families. Burson and Kramlich still hear from several of the people they helped. Parents ask them to update children who have died, something they almost never do, although last year they fulfilled the request of a dying mother to see what her five-year-old would look like at eighteen. The FBI licensed the software in 1987.

with a subject lying down under lights and staring, while the computer signaled each opportunity to blink. Burson believes MIT's interest in her project developed because, although advanced computer scientists could now record a live image onto a screen, they had no idea what to do with it next. Nicholas Negroponte, founder and director of MIT's Media Laboratory, gave her space and encouraged her, but she feels, without the belief that anything concrete would happen.

For two years she commuted to Cambridge, and in 1978 left MIT with a tape of three aging faces. *Family Health* magazine published the photographs in 1980; a wire service picked up the story; the next week phone calls came from all over the world. The *National Enquirer* dispatched a reporter to search MIT for "the black box"—the aging machine—which in reality was a tape, in Burson's possession.

The simulated aging process, for which Burson shared a patent with MIT engineer Tom Schneider, interpolates between an older and younger person by means of a database that stores templates of typical wrinkling and muscle-softening patterns. In an additive process, the computer determines facial type based on such considerations as gender, weight, and facial structure. Only in the last few years have the

In the mid eighties, Burson and Kramlich were working in a Staten Island mall, shooting photographs and testing a new computer process that superimposes subjects into heart-shaped valentines. Burson was having fun. While David was at lunch, a man maneuvered up a bed-wheelchair that held a palsied teenager, so severely handicapped that she was prone. The father asked that a valentine be made of his daughter. Burson rearranged the child's hair with a clip of her own, making an effort to get her to look "normal"— the first and last time she ever manipulated appearance before taking a photograph. After many shots, she took one in which the girl's tongue was in her mouth and all the elements of her handicap seemed in control. "We had a very nice picture," she remembers. "I didn't realize it, but a huge crowd had gathered. And her father was oblivious to the whole thing. He didn't care who was gawking, he only wanted a picture of his beloved daughter. For me, it spoke of unconditional love that I had never experienced."

Around that time, as Burson and Kramlich began to think of having children, she faced her anxieties: fear of having a deformed child, fear of having a child who would die. Confronting those apprehensions through her work, she created strange computer images scanned from medical books and manipulated to simulate known facial anomalies and produce new ones. From this process came the personal conviction of what she had seen in the Staten Island mall: the ultimate challenge was parental love without conditions. In 1990, with her son Keir now a year old, she exhibited her photographs in the Jayne H. Baum Gallery. Although they moved and interested many people, they shocked others. Burson in turn was shocked, for though the images were confrontational, to her they seemed beautiful. One angry doctor wrote that he was offended by Burson's intention to "deform a child artificially." In her reply to his letter, Burson wrote, "If looking at these images makes it any easier for us to look at the real faces of nature's mistakes, then I will have increased our awareness

Nancy Burson, *Untitled*, 1993

that the real ugliness in the world comes from within us—not outside. . . ."

"How do you get people to change their way of seeing?" Burson now asks. Her 1993 exhibition begins to answer that question, as does her book, *Faces*, published in 1993 by Twin Palms Press. In the book she sets images of real children with craniofacial conditions and progeria on pages tucked in between protective covers, safeguarded by the jacket image of a shadowed profile hovering above a child's face, luminous as the moon. Affection for her subjects glows from each photograph. And reflected pain is a mirror of the beholder, for in the majority of these photographs children smile, play, sleep, are visibly loved.

Near closing time, the gallery crowd at Burson's opening thins out. Only a few remain to try her computer "anomaly machine," in which the subject's face can be programmed to resemble some of the handicaps in the photographs. Sitting in the booth, a man stares at the video screen as his mouth slides down, as though felled by an instant stroke. He sighs loudly, gets up, and then a child darts under his arm into the seat. She bugs her eyes at the video screen and waggles her head before she calms down. As her father guides her through the program, her features dissolve and reform, eyes smaller and closer, jawline shaved, chin distorted. She looks at the screen intently, glances over at the wall where Burson's photographs hang, and smiles.

Aperture # 133, "On Location," elicited unusually strong response— most enthusiastic, some critical—from subscribers and members of the photographic community. Although we do not ordinarily run a Letters to the Editor column, we felt that one letter in particular, from the photographer Robert Adams, demanded publication. We invited Adam Fuss and Joel-Peter Witkin, whose work Adams addresses, to respond.

Our treatment of non-human animals has rightly become the subject of urgent public discussion. This has happened both because new technology is changing the way in which we touch the rest of the sentient world, and because as we look back over the century we are uneasy about our nature. Are we no more than predators? Might our behavior toward non-human animals contribute to the definition we are formulating of ourselves? And thus be predictive of the future?

Photography can help us with these questions. Complex images like Joel Sternfeld's *Exhausted Renegade Elephant, Woodland, Washington*, deepen our commitment to more compassionate behavior.

In the making of pictures there is, however, always a temptation to believe that they will be of absolute importance, that any sacrifice is appropriate to artistic ends. In *Aperture* #133 ("On Location") we learn that Adam Fuss has created a series of abstractions by placing the entrails of freshly killed rabbits on photographic paper. "A steady reserve of rabbit intestines from a local restaurant supplier allows Fuss to continue his work." Later in the same issue of the magazine Joel-Peter Witkin describes setting up a tableau for a picture called *Raping Europa*: "The white bull was too expensive, and the gray, spotted bull they sent over looked too much like a horse. So the owner of the slaughterhouse killed a white cow, cut it in half, and we had to drag this carcass of a half-cow into the palace [Witkin's studio in Budapest]."

Fuss's rabbits were dead already, but his use of their remains almost inevitably makes him an accomplice in the killing. I do not know if he paid for the intestines, but his taking of them certainly relieves the supplier of having otherwise to get rid of them. And if the supplier is as alert to the need for positive public relations as are most slaughter-house operators, it won't be long before Fuss's story is turned into an upbeat news release. Most important, however, Fuss has given the supplier a way to extinguish whatever may remain of unease in his or her own conscience; people outside the art establishment still tend to suppose, if naively, that much of what is called art is socially constructive; to have one's killing contribute to "art" will be a nice anodyne.

One also wonders about the effect on aspiring artists of Fuss's "success" (shows, magazine articles) when word of his method spreads, not always complete with information about how he got the viscera. There will be those who do not know a convenient restaurant supplier. And there will surely be some who, looking to establish an art-world identity, will feel compelled to experiment with entrails from other animals, all of which must, on Fuss's advice, be recently slaughtered.

The effect of Joel-Peter Witkin's casting call is, of course, not in question. A living animal was destroyed (and probably rendered inedible) specifically to make a prop. Yes, the cow would have died eventually. But so will we all.

To some degree, ends can justify means. Current photography of zoo animals belonging to endangered species is, for example, worrisome because it is stressful for the animals, but it is possibly defensible as it contributes to the survival of the species in the wild. What cannot be justified under any current circumstances, however, is killing an animal to make a picture (Audubon and other wildlife illustrators did it, but the practice has been made indefensible by the coming of high-speed photography). In the *Aperture* article about Fuss, his progression from making photograms with a live snake to making photograms with dead rabbits is described as "a small leap," but this is like claiming it was a small leap to begin destroying Vietnamese villages in order to save time.

In practice, pictures that involve serious, avoidable animal abuse by photographers are rarely defensible in any way. The ends pursued turn out to be, by some mathematics of the spirit, almost invariably trivial (even if announced histrionically) or harmful, often amounting to little more than a statement of unresolved confusion or horror.

This is not to deny the sincerity of those who created the pictures. But some of the saddest attempts at art are made by the most sincere people. Which, to bring the point home, places responsibility for what to do with their pictures squarely with each of us—whether to pay the pictures attention, or to turn away and thus deny them the support that finally makes, in concert with others' attention, their further distribution possible.

To be clear, I am not a vegetarian (though like many I try to eat less meat, and I look forward to the time when the food industry makes this easier). I do not believe that there are any vegetarians. Or, for that matter, any artists who make their pictures without, however indirectly, harming animals. To participate in our society as it is presently constituted is to harm animals. Which means that the goal is to harm as few as possible—to minimize suffering. Each of us is obligated, day after day, lifelong, to make relative distinctions.
—*Robert Adams*

Joel-Peter Witkin responds:
The essence of R. H. Cravens's writing on my work was about "the line between travesty and transfiguration." If Mr. Adams does not agree with this reading, that is his right. But I am reminded of the fable of the clown before the altar. Some thought it blasphemy; the aware knew it was the greatest act of love of which he was capable.

Adam Fuss responds:
I am attracted to Mr. Adams's views; I share many of them. Others have the ring of well-meaning paternalism. What I feel must be rejected are Mr. Adams's attempts to define what is or is not accept-

able artistic practice. Many of my generation have had to rebuff attempts from "political" and "religious" sources speaking from their perceived platform of moral superiority.

Undoubtedly life is precious to all that live—and the taking of that life is not a casual matter. I killed, ate, and photographed many rabbits. This doesn't seem so unusual to me. We kill and eat and use millions and millions of animals every year. Is it really so strange to try to make art with real animals? We are willing to exchange life for beliefs or nourishment—is not art as fundamental to our culture?

Man's earliest artistic images depict animals. Our myths and religious stories—even the dreams of modern men and women—are filled with images of animals. I feel strongly that by working with the real thing, the animal, its body, inside and out, I've been able to understand the place of that animal in an inner human world. The traveler doesn't travel through reading travel books.

So to Mr. Adams I say let time judge whether my art is "a sad attempt," or "a statement of unresolved confusion." And if I've erred God will judge me.

CONTRIBUTORS

GEOFFREY BATCHEN, an Australian cultural critic, currently teaches in the Visual Arts Department at the University of California, San Diego.

NANCY BURSON's photographs have been seen in numerous publications, including the *New York Times*, *Omni*, and *American Photographer*. She has appeared on both national and British television programs in connection with her computer-generated portraits.

PETER CAMPUS is an associate professor at New York University's Department of Art. He has also taught at the Massachusetts Institute of Technology (MIT) and the Rhode Island School of Design. His digital photographs were included in the 1993 Whitney Biennial.

BEN DAVIS is a research associate at the MIT Center for Educational Computing Initiatives and manager of the AthenaMuse Software Consortium. He has held numerous teaching posts, including as an instructor in the Visible Language Workshop at the MIT Media-Lab. Since 1986, Davis has managed and produced interactive multimedia projects at MIT.

TIMOTHY DRUCKREY is an independent curator and writer whose work focuses on photographic history, electronic media, and theory. He is the editor of *Iterations: The New Image* (MIT Press, 1994) and cofounder of Critical Press, which publishes monographs on technology and identity issues in postmodern culture.

DIANE FENSTER works as a computer artist and illustrator at San Francisco State University. Her images have appeared in a number of publications, including *Mac Art and Design*, *MacWeek*,

and *Print* magazine, and in CD-ROM packages published by Adobe, Sumeria, Inc., and Nautilus.

JONATHAN GREEN is director of the California Museum of Photography at the University of California, Riverside. He is the author of *American Photography: A Critical History* (Abrams, 1984) and is a former associate editor of *Aperture*.

BARBARA KASTEN lives in New York City. Her work has been exhibited internationally and is in the permanent collections of major museums in the United States and Europe. In 1985 the monograph *Constructs: Barbara Kasten* was published by the New York Graphic Society and the Polaroid Corporation.

VINCENT KATZ is a New York City–based poet. He is a regular contributor to *Art in America*, *ARTnews*, *Paper*, and the *Print Collector's Newsletter*.

ROSHINI KEMPADOO lives and works in England as a free-lance photographer for picture libraries, and as Photography Officer for West Midlands Regional Arts Board. She was formerly the coordinator and marketing manager for *Ten.8*, the international photography magazine. Her work has appeared in *Perspektief*, *Artforum*, and on a billboard in Birmingham, England.

BRENDA LAUREL is a researcher and writer whose work focuses on human-computer interaction and cultural aspects of technology. She is a member of the research staff at Interval Research Corporation, in Palo Alto, California; editor of the book *The Art of Human-Computer Interface Design* (Addison-Wesley, 1990); and author of *Computers as Theatre* (Addison-Wesley, 1991; 2nd edition 1993).

MARTINA LOPEZ is an assistant professor of art at the University of Notre Dame, and media coordinator at the Art Institute of Chicago. Her work was recently featured at "Montage 93: The International Festival of the Image," in Rochester, New York.

MANUAL is a team consisting of Ed Hill and Suzanne Bloom, both professors of art at the University of Houston. Their work was prominently featured in "Iterations" at the International Center of Photography Midtown, New York, and has appeared in *Afterimage*, *American Photo*, *Ten.8*, and many other publications.

ANIL MELNICK has worked as a free-lance photographer since 1991, and is currently enrolled as an M.F.A. Photography candidate at the School of Visual Arts in New York City. He has a B.A. in film from Vassar College, and formerly worked as a video producer for *Adweek* magazine.

PEDRO MEYER, one of Mexico's leading photographers, currently lives and works in Los Angeles. His photographs have been exhibited internationally, and are in the permanent collections of major museums around the world. For the last three years Meyer has concentrated his efforts on advanced visual-imaging technologies.

OSAMU JAMES NAKAGAWA received his M.F.A. in photography in 1993 from the University of Houston, where he held a two-year teaching fellowship. In 1993 his work was included in the National Graduate Seminar Exhibition at New York University's American Photography Institute.

For over twenty-five years GRAHAM NASH has received international renown as singer, musician, and songwriter with the Hollies and Crosby Stills & Nash. An avid art collector and photographer, he is currently publisher of Nash Editions.

ESTHER PARADA is a professor of photography at the University of Illinois at Chicago, and works as an artist and critic. Her writings on photography have appeared in *Afterimage*, *Exposure*, and *Aperture*, and her photographs have been published in *Newsweek*, *Frame/Work*, and *Feminist Studies*.

KATHLEEN RUIZ is a sculptor, photographer, and computer artist who teaches computer art at New York University and the School of Visual Arts in New York City. Her work has been exhibited nationally, and has been the subject of articles in *ARTnews*, *ARTI*, and *Computers in Art and Design*, among other publications.

SHELLY J. SMITH is an instructor and systems administrator in the M.F.A. Computer Art Department at the School of Visual Arts in New York City. Since 1990 her work has been included in group exhibitions in New York, Philadelphia, and Tokyo.

DEANNE SOKOLIN, an M.F.A. Photography graduate from the School of Visual Arts in New York City, has been a free-lance photographer and consultant since 1987. Her photographs have been exhibited in several shows on the East Coast, including at the Visual Arts Gallery in New York City and the Newport Art Museum in Rhode Island.

EVA SUTTON is a professor of digital photography and computer art, as well as a systems administrator at the School of Visual Arts in New York City. Her work has appeared in *Ten.8*, *Artweek*, and *Mondo 2000*.

PAUL THOREL has lived in Italy since 1964, and has been involved in electronic imaging since 1980, working in various media, including photography, video animation, interactive film, and electronic set design. His work has been seen in galleries and festivals throughout Europe, and has appeared in such publications as *Originale*, Italian *Zoom*, and *Photographie*.

ANNETTE WEINTRAUB lives in New York City and has exhibited her work across the country. In 1991 she received an Artist's Fellowship for Printmaking, Drawing, and Art Books from the New York Foundation for the Arts.

CREDITS

Unless otherwise indicated, all photographs were digitally created, altered, or enhanced, and are copyright by, and courtesy of, the artists. Sizes refer to exhibition format with height listed first.

Front cover: computer photomontage by Shelly J. Smith, output as a 30 x 40" Iris ink-jet print on cotton rag paper or cotton canvas; p. 1 digital photograph by Kathleen Ruiz, 8 x 10"; p. 2 digital photograph by Paul Thorel, 13 2/3" x 17 1/2"; p. 4 photocollage by John Heartfield, 14 1/2 x 11", courtesy the Kent Gallery, New York City; p. 5 photocollage by Hannah Höch, 11 1/8 x 11 1/8", initialed *H.H.* at lower left in composition, courtesy of Barry Friedman Ltd., New York City; p. 7 photograph by Andy Warhol, synthetic polymer paint and silk-screen ink on canvas, 106 x 82", from the Menil Collection, courtesy of The Andy Warhol Foundation for the Visual Arts, Inc., New York City; pp. 8–11 computer photomontages of varying dimensions by Eva Sutton, output by film recorder onto black-and-white sheet film, printed onto photo-sensitized linen or paper, and selenium toned; pp. 12–17 computer photomontages by Martina Lopez, output to a 4-by-5-inch high-resolution film recorder and enlarged as Cibaprints, courtesy Gallery 954, Chicago; pp. 12, 13, 16, and 17: 30 x 50", pp. 14-15: 22 x 90"; pp. 18–19 computer-altered photographs by Anil Melnick, output as 30 x 30" and 24 x 35" Iris ink-jet prints; pp. 20–23 computer photomontages by Shelly J. Smith, output as 30 x 50" Iris ink-jet prints on cotton rag paper and cotton canvas; pp. 24–25 computer photomontages by Roshini Kempadoo, 60 x 33" color photographic images mounted onto board covered with gloss laminate; pp. 26–29 computer-altered photographs by Osamu James Nakagawa, output as 26 1/2 x 40" Type C prints; pp. 30–31 computer photomontages by Esther Parada, 21 x 41" and 33 x 55" tiled color ink-jet prints; pp. 32–37 computer-altered photographs by Pedro Meyer, output as 36 1/2 x 24 1/2" Iris ink-jet prints; pp. 38–43 Iris ink-jet prints on cotton rag paper of varying dimensions, courtesy of Nash Editions, Manhattan Beach, California; pp. 44–45 computer photomontage by Annette Weintraub, output as 31 x 47" tiled and laminated laser print; p. 47 digital photographs by Deanne Sokolin, output as 10 x 11" thermal dye-sublimation prints; p. 48 digital photograph by MANUAL (Ed Hill and Suzanne Bloom), output as 24 x 36" Type C print; p. 49 digital photograph by Diane Fenster, from still and live color video images, output as a 20 x 30" Fujichrome print; pp. 50–51 digital photographs by Kathleen Ruiz, output as 8 x 10" thermal dye-sublimation prints; pp. 52–53 computer-altered photographs by Peter Campus, 39 1/4 x 56 3/4" and 39 7/8 x 62 3/4" courtesy of Paula Cooper, Inc., New York City; pp. 54–59 computer-altered photographs by Barbara Kasten; pp. 56–57 composite of five images, painted with jet-spray on vinyl and presented as a backlit box, 42 x 14" or 10 x 3 1/2"; all others are natural-light color transparencies printed as Cibachromes and/or jet spray murals, 30 x 40" or 50 x 66"; p. 60–65 digital photographs by Paul Thorel; p. 60: 8 1/2 x 8 1/2", p. 61: 15 1/2 x 17 1/2", p. 62: 18 x 18", p. 63: 15 1/2 x 15 1/2", p. 64: 26 1/2 x 58 1/2"; p. 65: 8 1/2 x 8 1/2"; p. 66 photograph by Ben Davis, © The Harold E. Edgerton 1992 Trust; p. 67 photograph by Ben Davis, courtesy the MIT Center for Educational Computing Initiatives; pp. 68–70 stills from Placeholder by Brenda Laurel and Rachel Strickland; project funded by Interval Research Corporation, Palo Alto, California; pp. 71–73 photographs by Nancy Burson; p. 71, left: 24 x 20" Polaroid Polacolor ER Land-film print; right: 28 3/8 x 23 7/8"; pp. 72–73: 15 x 15" gelatin-silver prints, all courtesy of the Jayne H. Baum Gallery, New York City.

ACKNOWLEDGMENTS

There are many people who helped make "Metamorphoses: Photography in the Electronic Age" possible. Charles Traub, at the School of Visual Arts in New York City, was especially helpful at the outset of this project, and put us in touch with a number of talented younger artists working in digital media. For bringing an impressive array of computer artists to our attention, we are also very grateful to Judy Dater; Ray DeMoulin; Timothy Druckrey; Katrin Eismann at the Center for Creative Imaging in Camden, Maine; Vernon Esell at Gallery 954 in Chicago; Joseph Fung, at the Swire School of Design in Hong Kong; Ginette Major, at La Cité des Arts et des Nouvelles Technologies in Montreal; Mike Mandell; Esther Parada at the University of Illinois; Mark Sloan; Charles Wiese at the University of Houston; and Sylvia Wolf at the Art Institute of Chicago. For their efforts, we also extend thanks to the Jayne H. Baum gallery in New York City, and Pilar Perez Associates of Santa Monica, California.

ISBN: 0-89381-602-7
Library of Congress Card Catalog No.: 94-76862

Art director/jacket design: Yolanda Cuomo

The staff at Aperture for
Metamorphoses: Photography in the Electronic Age is:
Michael E. Hoffman, Executive Director/Editor in Chief
Roger Straus III, Publisher/General Manager
Michael Sand, Editor
Wendy Byrne, Designer
Stevan Baron, Production Director
Sandra Greve, Production Manager
Michael Lorenzini, Editorial Assistant
Diana C. Stoll, Copy Editor
Lena Skadegård, Editorial Work-Scholar

Front cover: Shelly J. Smith, *Untitled Nanbird*, 1992
Page 1: Kathleen Ruiz, *Enumerated Repository F*, 1991

Color separations by Citiemme SRL, Torino, Italy.
Printed and bound in Hong Kong by Everbest Printing Co., Ltd.

Aperture Foundation publishes a periodical, books,
and portfolios of fine photography to communicate with
serious photographers and creative people everywhere.
A complete catalog is available upon request.
Address: 20 East 23rd Street, New York, New York 10010.

First edition
10 9 8 7 6 5 4 3 2 1

An exhibition of
"Metamorphoses, Photography in
the Electronic Age,"
sponsored in part by
the Fashion Institute of Technology,
will be on view from September 8
through October 29, 1994 at
The Museum at FIT, New York City,
and will travel nationally.